IMAGES
of America

HUNTSVILLE
PENITENTIARY

D1453133

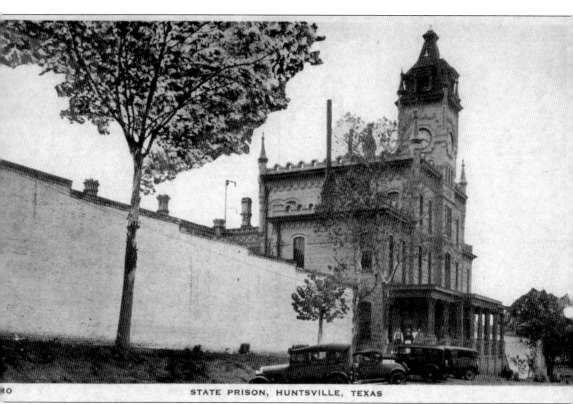

This postcard view of the administration building of the Huntsville Penitentiary was taken from the southwest corner in the late 1920s. Note the clock tower and the brick wall. Prison employees can be seen standing on the front porch. This structure was replaced with a new administration building that opened in 1942. (Courtesy of the Texas Prison Museum.)

ON THE COVER: Inmates are pictured at a 1911 Fourth of July gathering in the courtyard of the Huntsville Penitentiary, with the prison hospital in the background. Following a legislative investigation into abuses throughout the prison system, a prison reform law had gone into effect in January 1911. A new system of registering convicts had been implemented, requiring that all incoming inmates be photographed. The white uniforms shown on the convicts were also a new addition, replacing striped uniforms (the stripes would continue to be used for incorrigible inmates). Huntsville was increasingly reserved for white convicts, with African Americans being sent to prison farms. The recently reelected governor of Texas, Oscar Colquitt, who had campaigned with promises to improve prisons and ban the use of the whip as punishment, visited the Huntsville Penitentiary for the Fourth of July picnic. (Courtesy of the Texas Prison Museum.)

IMAGES
of America

HUNTSVILLE
PENITENTIARY

Theresa Jach
Foreword by Jim Willett

ARCADIA
PUBLISHING

Published by Arcadia Publishing
Charleston, South Carolina

Printed in the United States of America

Library of Congress Control Number: 2012956012

For all general information, please contact Arcadia Publishing:
Telephone 843-853-2070
Fax 843-853-0044
E-mail sales@arcadiapublishing.com
For customer service and orders:
Toll-Free 1-888-313-2665

Visit us on the Internet at www.arcadiapublishing.com

This volume is dedicated to the wonderful people at the Texas Prison Museum who have made it their mission to preserve the important history of the Texas prison system.

CONTENTS

FOREWORD

The importance of the state prison system to Huntsville, Texas, cannot be overemphasized. It is hard to imagine what our town would be like without the prisons, the jobs they afford, and their assistance to our community and the overall welfare of our town. Having the headquarters for a state agency—the Department of Criminal Justice—located here in addition to the five prisons inside our city limits is a huge boost to our economy. The general public can learn a lot about their prison system by visiting the Texas Prison Museum, rightly located in Huntsville, Texas.

—James Willett
Director of the Texas Prison Museum

ACKNOWLEDGEMENTS

Unless otherwise noted, the images in this volume are from the collection of the Texas Prison Museum. Former employees and their families have donated photographs to the museum's archive, providing an important resource for historians and history buffs alike. Other images were provided by the Texas Department of Criminal Justice (via the Texas Prison Museum), the Texas State Libraries and Archives, and the Thomason Room archive at Sam Houston State University.

Special thanks go to Jim Willett, the director of the Texas Prison Museum, and Sandy Rogers, the museum's registrar and archivist. They provided invaluable access to photographs in their collection and willingly shared their vast knowledge about the prison. Sandy graciously met me on her day off and even gave me a tour of Huntsville. I would also like to thank my husband, Tim, for listening to all of my "prison stories," and my colleagues at Houston Community College-Northwest for their interest in this project.

INTRODUCTION

The State of Texas opened its first prison in 1849 in Huntsville, located in Walker County, about 70 miles north of Houston. A three-member board appointed by Gov. George Wood chose this location. When built, this new penitentiary was to serve as an alternative to more barbaric practices of capital and corporal punishment for crimes. Penitentiary advocates hoped these facilities would rehabilitate offenders, making them productive members of society, while at the same time protecting citizens from danger. This first step foreshadowed the development of one of the largest prison systems in the world. Construction on the first building began on August 15, 1848, under the supervision of architect Abner Hugh Cook. While the main cell block was being built, a temporary wooden jail was constructed on the property to house the first convicts. Once the main building was complete, Cook was to utilize convict labor to complete the prison and the surrounding wall required by the legislature. The legislature also mandated the inclusion of a sturdy surrounding wall to enclose the prison building and grounds. The prison would soon earn the nickname "the Walls" for the brick structure enclosing the cell blocks and courtyard. The first prisoner, convicted cattle thief William Sansom of Fayette County, arrived in October 1849. By January 1850, there were three inmates at the Huntsville Prison. The second to arrive, convicted murderer Stephen Terry of Jefferson County, has the dubious distinction of being the first inmate shot and killed by guards while trying to escape; he had been in Huntsville for less than a year. The first female inmate, Elizabeth Huffman, served a one-year sentence, beginning in 1854, for killing her newborn infant.

The number of inmates remained small before the Civil War, when only white men were routinely subject to punishment by the state. For example, in January 1855 there were 75 inmates at the prison. Although there were relatively few inmates, Texas politicians were determined to create a self-sustaining prison that would not burden taxpayers. In 1853, Gov. Peter Bell requested a $35,000 appropriation to build a textile mill at the facility. Producing cotton and wool cloth, the prison earned a profit selling rough material for slave clothing. During the Civil War, the prison textile mill also generated a significant profit with the production of cloth for Confederate uniforms. Following the war, the inmate population in Texas grew dramatically, altering the system and leading to new efforts to find more income from convicts. While Huntsville continued to operate various moneymaking enterprises, the bulk of the prison system's income came in the form of convict leasing. This system, which was in place until 1914, saw thousands of prisoners leased to privately owned cotton and sugar plantations. The majority of leased convicts were African American. Some white convicts were leased to railroad companies. As the state moved away from the brutal lease system, they began purchasing farms on which to put convicts to work. These farms served as the basis for a prison system that spread across that state and now encompasses nearly 50 prison units (not including various facilities operated by the Texas Department of Criminal Justice, such as transfer facilities, psychiatric facilities, or prerelease facilities). Huntsville remains as the hub of the system today. Ephram Stephenson designed the current incarnation of the prison. Work on remodeling much of the prison began in 1934, and Stephenson oversaw the

building of an arena for the prison rodeo and the redbrick wall that surrounds the facility today (the old sandstone brick wall was covered over with a redbrick facade). He also designed the new redbrick administration building.

Huntsville has housed many notorious criminals. Infamous gunslinger and convicted murderer John Wesley Hardin arrived at the Walls in 1878. There were also numerous escapes and attempted escapes. The most noted occurred in 1934 when three inmates escaped from death row in Huntsville. Among them was a member of the Bonnie Parker and Clyde Barrow gang, Floyd Hamilton. In 1935, Raymond Hamilton (Floyd's brother) and Joe Palmer, two other Barrow gang members, were executed via the Huntsville electric for the murder of a prison guard during an escape attempt at the Eastham Prison farm. Jazz musician Jack Purvis spent time in Huntsville in the 1930s as well. In 1974, a failed escape attempt by drug kingpin Fred Carrasco led to the longest siege in US prison history. In 1998, Karla Faye Tucker, who was convicted of a gruesome pickaxe murder in 1984, became the first woman executed in Texas since 1863. Serial killer Henry Lee Lucas, after having his death sentence commuted to life in prison, died of heart failure in Huntsville in 2001.

Since 1923, the state's execution chamber has been located at the Huntsville Unit. Before 1923, hanging was the method of execution utilized in Texas, and these executions were carried out in the jurisdiction where the crime was committed. After 1923, all executions were carried out at the Huntsville Unit. The first executions in the electric chair in Texas occurred on February 8, 1924, when five men were executed within a few hours of one another. From 1924 to 1964, the electric chair was used in the execution of 361 convicted persons. The last time multiple executions took place in a single day was in 1951. When the US Supreme Court banned the use of the death penalty in 1972, fifty-two death row inmates in Texas saw their sentences commuted to life in prison. In 1976, the US Supreme Court reversed its decision and allowed the use of the death penalty once again, although Texas would not execute another prisoner until 1982. By that point, the electric chair was no longer in use, and lethal injection became the standard method to execute condemned inmates. Between 1982 and November 2012, Texas saw 492 inmates executed, more than any other state.

While the number of executions caused much notoriety, the Texas prison had other aspects that brought it national attention. In 1931, the Walls became the home of the Texas Prison Rodeo, a popular event that drew entertainers from around the country. Spectators enjoyed watching convict cowboys performing rodeo staples like bull riding and calf roping. Inmates also performed at the rodeo, with notable examples including the Goree Girls, a string band made up of female inmates. Hundreds of people traveled to Huntsville each year to enjoy the Prison Rodeo, which brought in much-needed funds for the system and also served as a source of recreation for inmates and an economic boost for the city of Huntsville.

Following World War II, the prison underwent a period of reform under the direction of prison general manager and director Oscar B. Ellis. Ellis, who served in that capacity until 1961, oversaw many improvements in conditions for both convicts and employees. Under his tenure, wages for guards increased, escapes dropped dramatically, and the reputation of the Texas prison system was enhanced.

A vital part of the Texas Department of Criminal Justice, the Walls occupies nearly 55 acres in downtown Huntsville and today has the capacity to hold just over 1,700 inmates. The headquarters of the Texas Department of Criminal Justice are located there, and it is the largest employer in the city, providing more than 6,500 jobs. The history of the Huntsville Unit provides both a window into the criminal past of Texas and an opportunity to explore the lives of the men and women who worked for the system. This volume provides a glimpse of the lives of the guards, administrators, and convicts, as well as a look at the architecture of the prison itself and the various administrative and housing structures associated with it. The Walls has served as an important part of the history of Huntsville, of Walker County, and of the state of Texas.

One

THE PRISON
AND CONVICTS

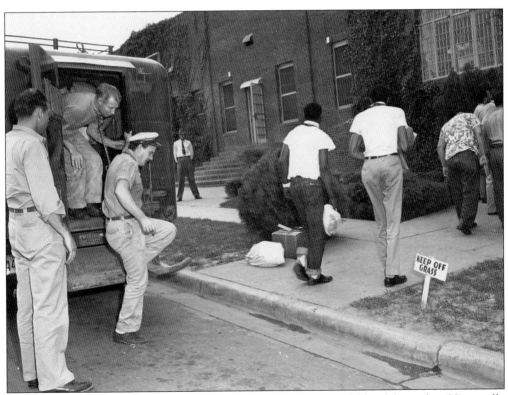

Following a conviction in their local jurisdiction, inmates would be delivered to Huntsville in a transfer vehicle. In the early days of the penitentiary, local sheriffs were paid by the state to deliver the inmates. The new convicts in this photograph from the 1950s were delivered to the administration building, where they would be processed—a procedure that included being photographed and measured, being given a brief physical, and having civilian possessions cataloged and stored. They would then be given prison uniforms and assigned to a cell.

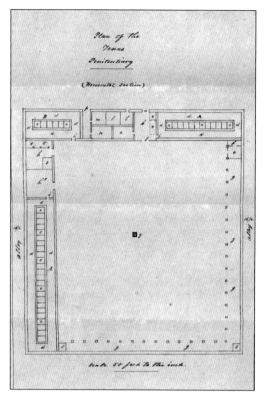

Plan of the
Texas
Penitentiary

(Horizontal Section)

alley

Scale 50 feet to the inch.

This architectural drawing of the Huntsville Penitentiary dates to 1848. In 1829, when Texas was part of Mexico, there were discussions about building a modern penitentiary. However, nothing came of those efforts. After the Texas Revolution in 1836, the Republic of Texas had no money to fund such a project, and it would not be until Texas was annexed by the United States in 1845 that the Texas Legislature would pass a penitentiary bill. The onset of the Mexican-American War in 1846 further delayed the project until 1848, when these plans were commissioned. The Texas Penitentiary was to follow the Auburn plan, with solitary cells, communal work areas, and a yard surrounded by a secure wall. The legislature required room for workshops to employ prisoners in useful pursuits to aid convict rehabilitation. (Plan for the Texas Penitentiary, August 15, 1848. Correspondence Concerning the Penitentiary, Records Relating to the Penitentiary, Archives and Information Services Division, Texas State Library and Archives Commission.)

Pictured here is Abner Hugh Cook, the architect of the prison. Cook moved to Texas in 1839, three years after the Texas Revolution. After working for a time building furniture and private homes, he became a partner in a lumber mill in Bastrop. In 1847, he built a home for one of the wealthiest men in Texas, Thomas William Ward, who happened to be the commissioner of the General Land Office. That connection probably led to Cook being chosen to design and supervise the building of the first Texas penitentiary. Following his prison commission, Cook went on to design many impressive buildings in the state, with one of his last undertakings being a construction project for the newly founded University of Texas. Cook died in 1884.

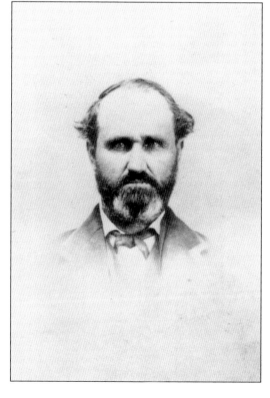

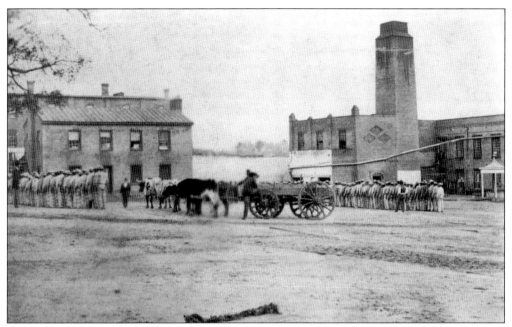

This early interior view of the prison dates to the 1870s or 1880s. Convicts are lined up for a work detail, and a prison wagon sits in the center of the courtyard. Guards are visible in front of the wagon.

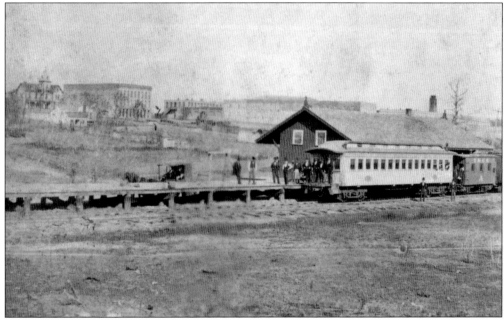

The Walls Unit is visible in the background of this photograph taken from the Huntsville train depot. The Huntsville Branch Railway connected the city to the larger Houston & Great Northern Railroad, located seven miles north of Huntsville. The railway was completed in March 1872, and this photograph was taken sometime between 1872 and 1875. Prison officials, politicians, and some convicts arrived in Huntsville on this railway. (Courtesy of Thomason Room, Sam Houston State University.)

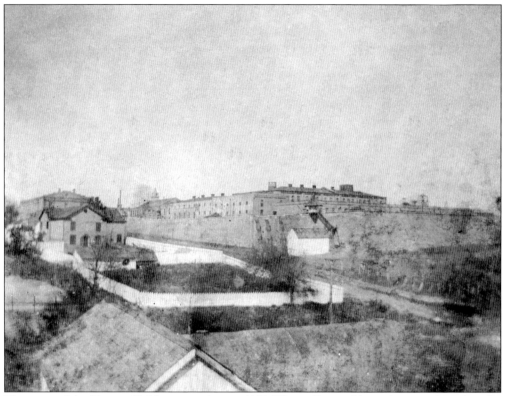

This view of the Huntsville Unit was taken in 1899. The wall is visible, and it is evident that the expansive prison covers a large part of the town.

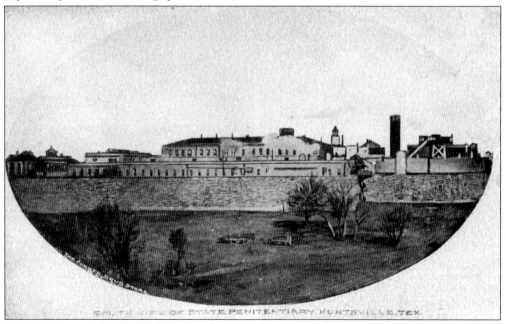

This 1907 postcard is a view from outside the Walls Unit. It shows the cabinet shop, one of the many work options for inmates.

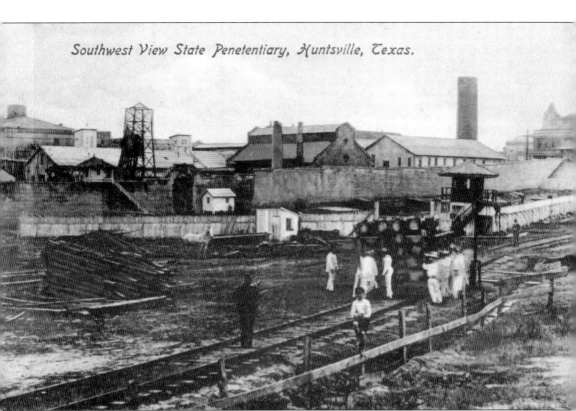

Southwest View State Penetentiary, Huntsville, Texas.

This is another exterior view of the prison, taken from the railroad tracks to the southwest. Convicts are visible in the foreground.

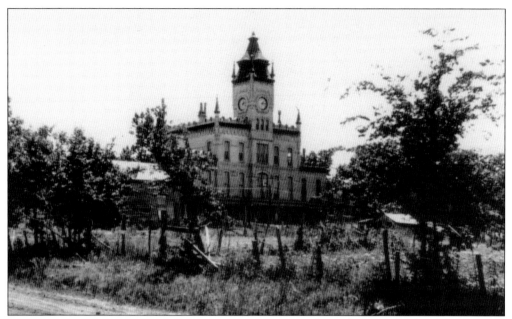

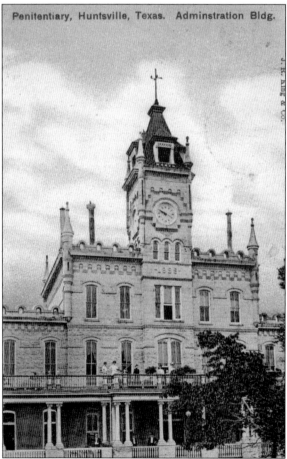

Penitentiary, Huntsville, Texas. Adminstration Bldg.

These photographs show the first administration building. The earlier image, above, does not include the wall or the front porch, while the postcard at the left does show the porch. The clothing worn by the women in the second photograph indicates that it was likely taken in the 1890s. The administration building, which housed prison officials, was the public face of the prison system.

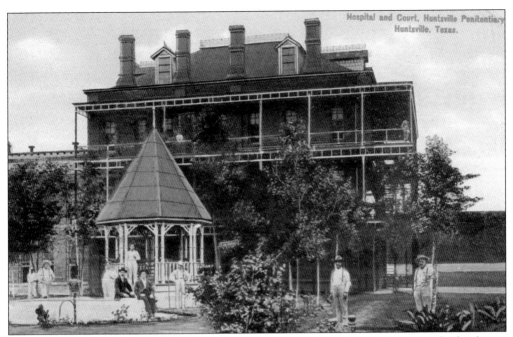

Ill and injured convicts were treated at the prison hospital, seen here. The prison had a doctor on staff, assisted by several inmates serving in various capacities. The dark-suited men sitting on the fountain in front of the gazebo are unidentified prison employees. The men dressed in all white or stripes are convicts.

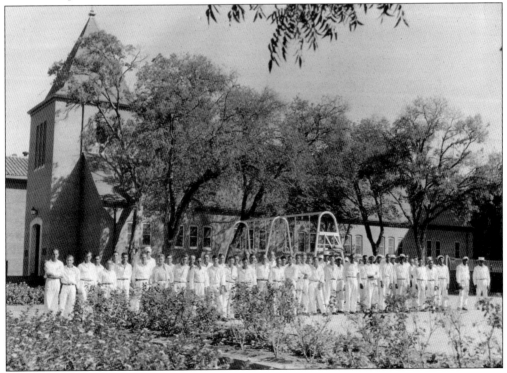

Prisoners stand in front of the chapel in the lower yard.

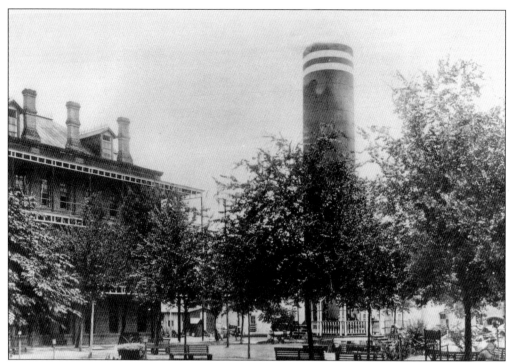

In this photograph from the upper yard, the hospital is visible on the left. The gazebo is in the center, under the trees. The benches provided seating during various programs for both inmates and employees.

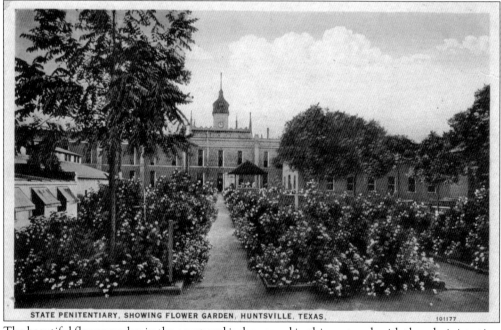

STATE PENITENTIARY, SHOWING FLOWER GARDEN, HUNTSVILLE, TEXAS.

The beautiful flower garden in the courtyard is showcased in this postcard, with the administration building visible in the background. The courtyard was often visited by the families of prison employees and officials, and its garden was tended by convicts.

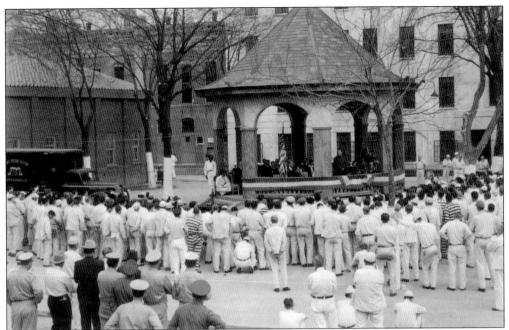

The courtyard's updated gazebo, now called the bandstand, is pictured here. The sturdier brick gazebo was used for music programs and visiting dignitaries. Later, this space would be completely enclosed to house the prison library. While most of the inmates are dressed in white uniforms, there are a few wearing stripes, identifying them as incorrigible prisoners.

In this closer view of the bandstand, the horse-head fountain is visible in front. The fountain, made of cast iron, was likely created at Rusk Penitentiary, the location of a prison-operated blast furnace. The inmates at Rusk also produced the ornamental ironwork used in the state capitol building in Austin.

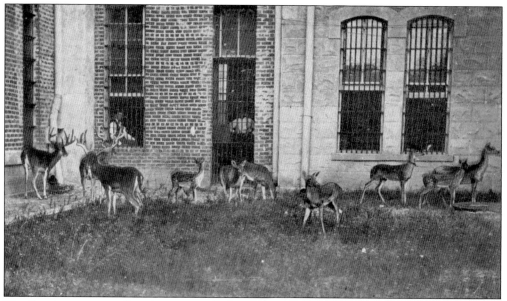

The "penitentiary pets," as they were called, are shown inside the walls in this 1920s postcard. Inmates and guards alike enjoyed feeding the deer, as demonstrated by the guard at the window to the left.

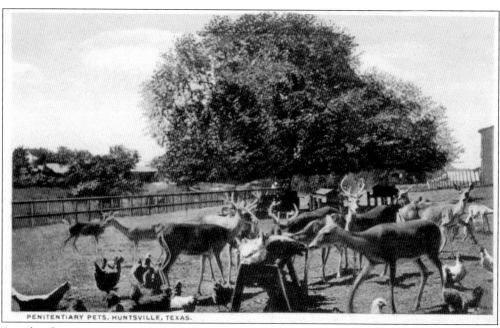

PENITENTIARY PETS, HUNTSVILLE, TEXAS.

Another humorous postcard highlights penitentiary pets, with deer and chickens wandering together inside the prison courtyard.

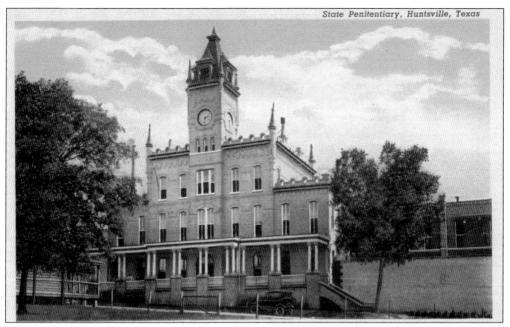

This view of the administration building from the 1910s shows the porch, the wall, and the clock tower.

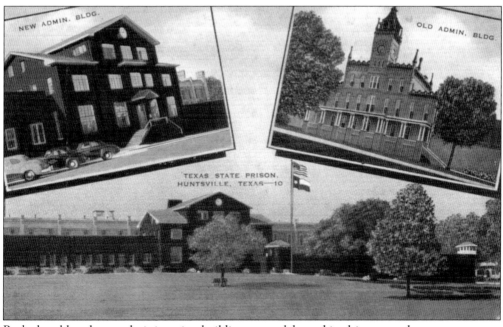

Both the old and new administration buildings are celebrated in this postcard.

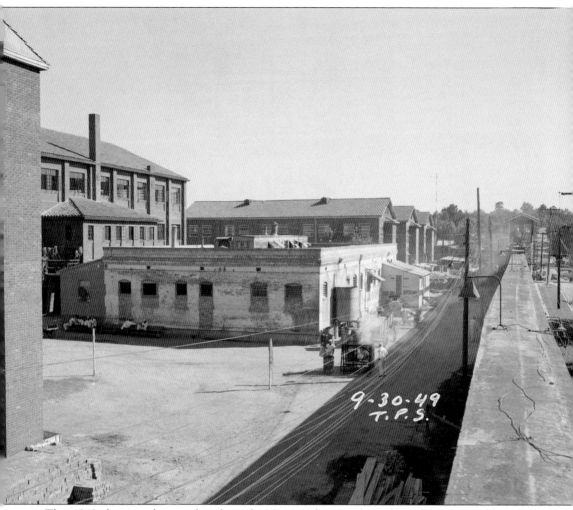

This 1949 photograph was taken from the No. 8 picket. To the right is the prison wall, and the low, white building is the prison laundry. The three two-story buildings behind it are the mattress, shoe, and print shops. In the far background, slightly to the left of the wall, Sam Houston State University is visible on the hilltop.

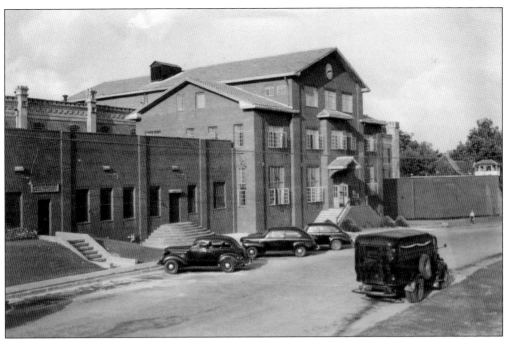

The administration building is shown here in the early 1950s. The transport vehicle, nicknamed "Black Betty," is on the right, and a picket tower can be seen in the center right.

This eastward-facing photograph was taken from the West Gate in the 1940s.

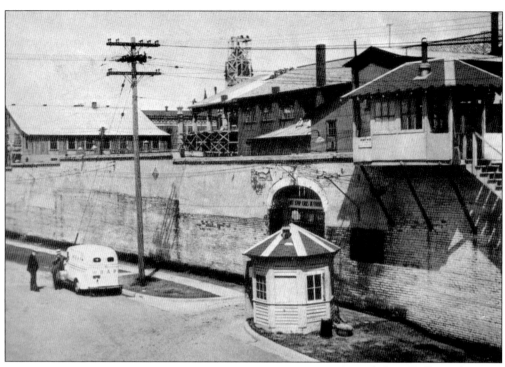

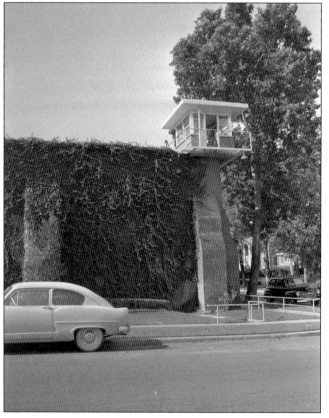

A truck from Dallas radio station WPBA is parked near the West Gate of the prison. Based on the car and clothing, this photograph appears to be from the 1930s. It is possible that the radio personnel were on site to report on the attempted escape of Barrow Gang members Ray Hamilton and Joe Palmer.

This is a view of picket No. 8 from the late 1950s.

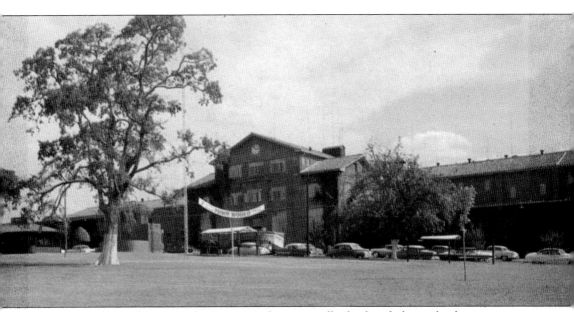

In 1950, a banner advertising the Prison Rodeo is proudly displayed above the front entrance of the new administration building. At the time of this photograph the building was less than a decade old.

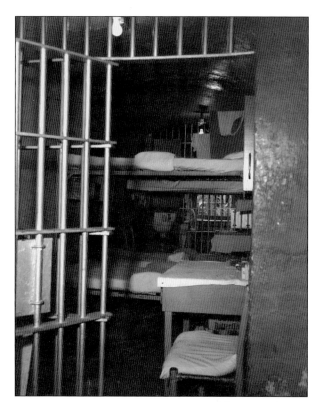

This photograph from the 1940s shows a cell in the old West Building. These were the only cells with two doors (the second door is visible in the back, just right of the sink).

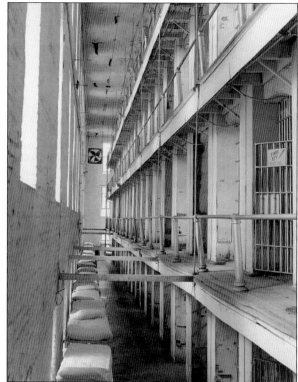

The old West Building is pictured again here. Due to overcrowding, some inmate beds are placed in "the run," the walkway between the wall and the cells.

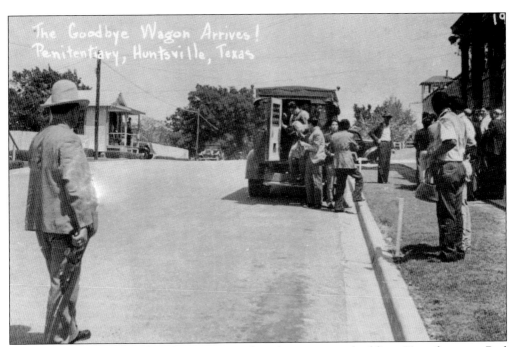

New inmates are pictured as they arrive at the administration building. Transfer agent Bud Russell stands to the left holding a gun in case anyone tries to make a run for it. This van was referred to as the "Goodbye Wagon." (Courtesy of the Robert Russell Collection at the Texas Prison Museum.)

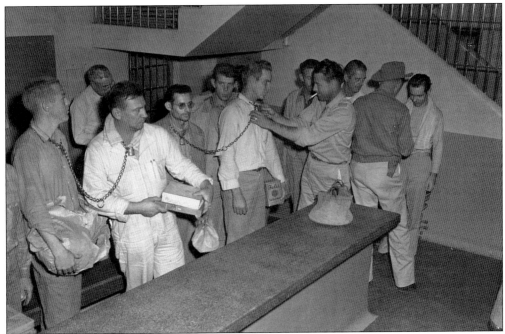

After being unloaded from the transfer wagon, new inmates are brought to the "bull ring," where they will have the neck chain removed and be checked into the prison. Note that the men are carrying their personal belongings in paper bags and cardboard boxes.

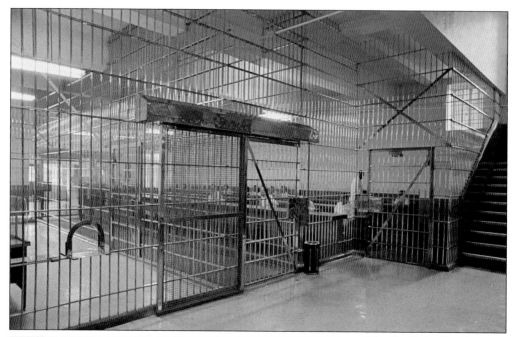

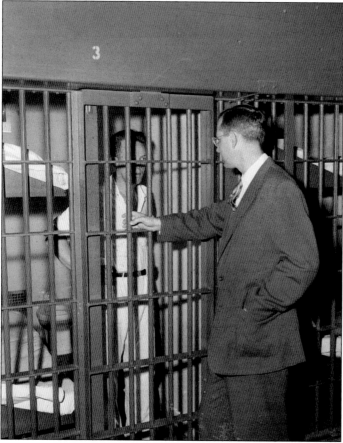

The "bull ring" is the center of the unit. This is where newly arrived convicts are processed into the prison. To the left, the half-circle opening in the bars indicates the location of the commissary, where inmates can purchase various items. This photograph is from the 1950s, taken after a remodel of the Walls Unit.

Here, a prison official talks to an inmate. Also visible are the cell's toilet and two bunks.

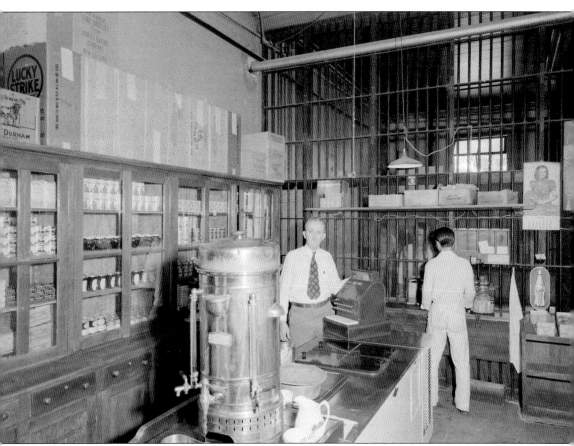

The inside of the commissary is pictured here in 1940, with inmates lining up outside to purchase items, such as food and cigarettes. In the upper left, boxes of Lucky Strike cigarettes and Bull Durham tobacco are stored, and in the glass cabinets are boxes of cigars, soup, and jars of jam. In the center are a large coffee urn and an in-counter cooler that held cold sodas. Two Coca-Cola calendars are visible to the far right.

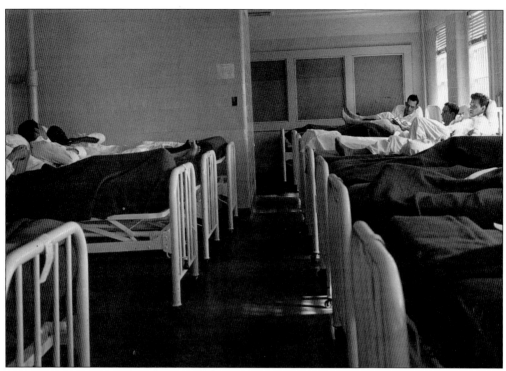

Inmates recover from illness and injury at the prison hospital. The more-comfortable accommodations of the hospital ward were coveted, and inmates would often attempt to feign illness or inflict injury upon themselves in order to be sent there.

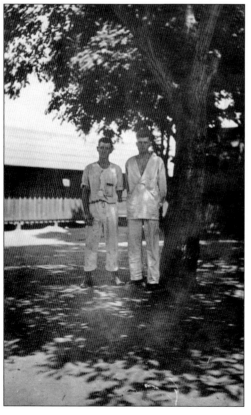

Two prisoners are pictured standing by a tree in the courtyard. Given their unkempt appearance, it is likely they were on a work detail, possibly gardening.

Viewed from the walkway above, two inmates are receiving haircuts at the barbershop, which was set up in the run and manned by convict barbers.

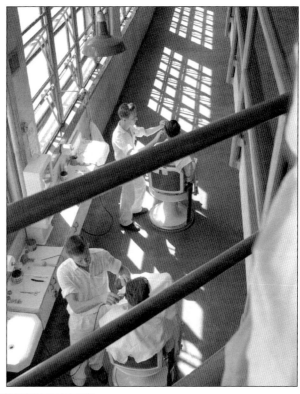

These two very different inmates are walking across the prison yard toward the barbershop.

There was little privacy at the shower facilities at the Walls, as seen in this 1940s photograph.

Guards perform a shake down, checking these prisoners for contraband. Periodic checks for weapons were an important part of the prison security, both for the guards and the inmates.

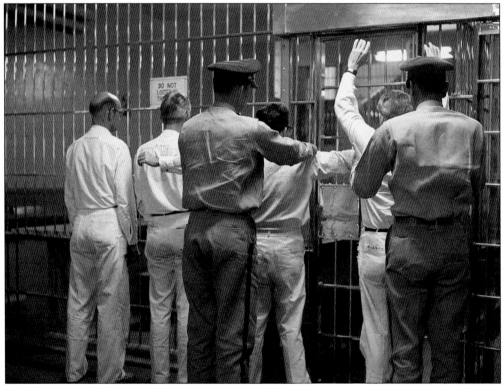

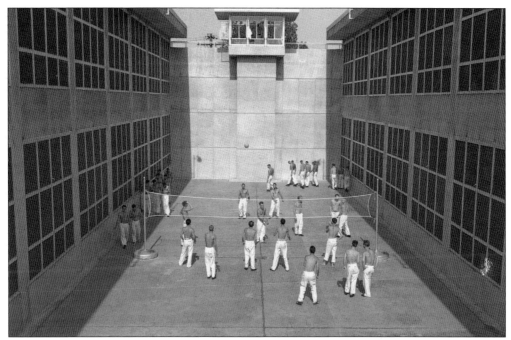

Troublesome inmates were segregated from the rest of the population and even had a separate, small courtyard for their exercise area. Here, some of these dangerous inmates are playing a game of volleyball under close supervision from the guard in the picket above.

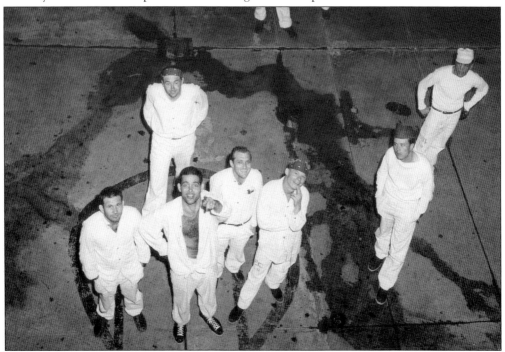

The segregated area for incorrigible inmates was facetiously known as the "Shamrock," as in the Shamrock Hotel. In this photograph, segregated inmates have refused to return to their cells and seem to be enjoying having their picture taken.

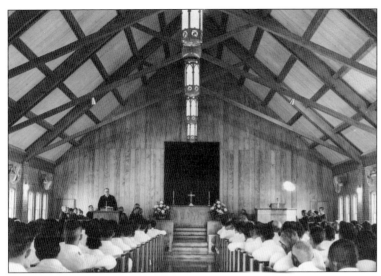

Inmates listen to a 1967 sermon in the Chapel of Hope.

A prisoner is released from custody in front of the administration building. The man is sent off with good wishes from the prison chaplain. During the first prison lease, in the 1870s, released inmates were given a new set of clothing and $20. There were no provisions made for transportation away from Huntsville, though, and local citizens complained bitterly about former inmates hanging around the town, causing trouble. Prison officials complained that many townspeople tried to lure ex-convicts into bars and brothels to trick them out of their money. By 1880, Superintendent Thomas Goree insisted that ex-convicts also be provided with transportation to their home county.

Two

Prison Employees, Their Families, and Their Homes

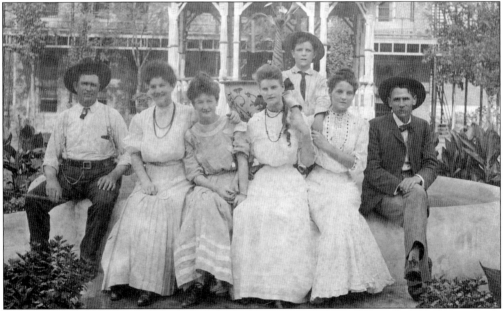

The family of Robert H. Underwood is pictured in front of a fountain in the prison courtyard. Underwood served as the assistant superintendent from the 1890s through 1907 and as warden of the Huntsville Unit from 1907 to 1911. Underwood was married to Bettie West, and they had seven children—Walter, Adele, Robert, Nettie Lee, Evelyn, Mabel, and John. The two older sons, Walter and Robert, worked at a local bank. This photograph appears to include, from left to right, Robert H., Bettie, Nettie Lee, Evelyn, John, Mable, and an unidentified man (probably Walter or Robert.) Underwood twice served as a delegate to the American Prison Association, delivering speeches on both occasions about prison discipline. However, in a 1909 exposé about prison corruption, Rev. Jake Hodges suggested to San Antonio Express investigative reporter George Waverly Briggs that Underwood and his relative, a guard named Mr. Ezell, were often intoxicated while at work.

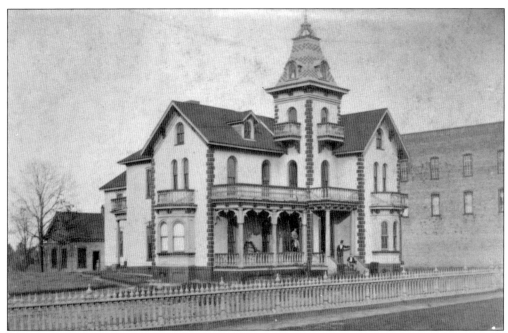

In 1871, the State of Texas leased the entire penitentiary and all of the inmates to the Ward, Dewey, and Patton Company of Galveston. Andrew "A.J." Ward, a former prison official in the state of Arkansas, was at the center of numerous scandals involving mistreatment of convicts and inappropriate behavior with female inmates. After a legislative investigation, the state removed Ward, Dewey, and Patton as lessees and replaced them with Edward H. Cunningham and Littleberry Ambrose Ellis. These 1874 photographs show views of Ward's home (above) and the front of the prison (below). The close proximity of Ward's home (which can also be seen in the far left of the image below) to the prison was the focus of much community concern when rumors began spreading that Ward spent a great deal of time with the prison's female convicts. During Ward's time as the lessee, locals began referring to the prison as the "Penitentiary Whorehouse." Female convicts during this period worked as domestic servants in the homes of prison employees and townspeople. (Courtesy of the Thomason Room at Sam Houston State University.)

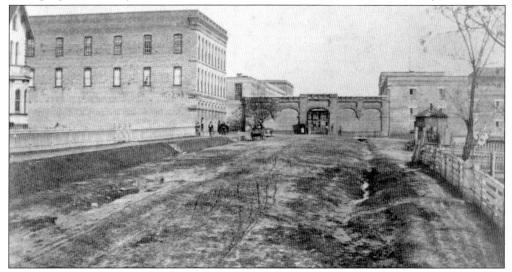

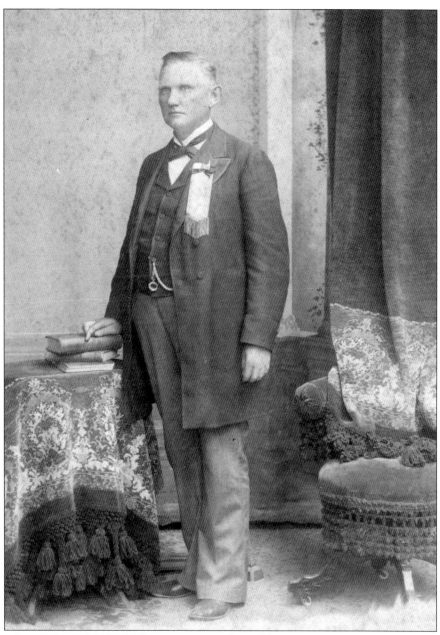

Thomas Jewett Goree (1835–1905) was superintendent of the prison from 1877 to 1891. Before the Civil War, Goree earned a law degree from Baylor College. As a captain in the Confederate army, he served as Maj. James Longstreet's aide-de-camp. Following the Civil War, Goree returned to Huntsville. He served on the board of directors of the Texas Penitentiary before being appointed superintendent. Under his direction, the penitentiary established a library, a school, and weekly church services for convicts. Goree's wife, Elizabeth Thomas Nolley Goree, had served as the head of the Andrew Female College in Huntsville until their marriage in 1868. Nicknamed "Tommie," she taught Sunday school to convicts and was deeply concerned about their welfare. She reportedly attended every convict funeral at Huntsville while her husband was the superintendent, often as the only person in attendance.

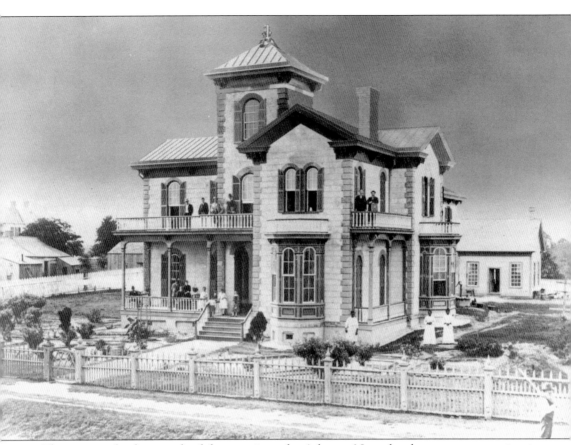

This is an early photograph of the superintendent's home. Note the three women convicts in white standing in the front yard to the right of the house. This image appears to predate 1899, at which point a more ornate gate—which remains today—was placed on the property. (Courtesy of the Thomason Room at Sam Houston State University.)

The younger brother of Superintendent Thomas Goree, Edward King Goree also worked for the prison for many years. He had served in Hood's Brigade during the Civil War. In 1864, he suffered a serious wound to his right leg at the Battle of the Wilderness and was held as a prisoner of war until April 15, 1865, after Gen. Robert E. Lee surrendered at Appomattox. At the time of his death in 1914, he held the position of criminal registrar at Huntsville.

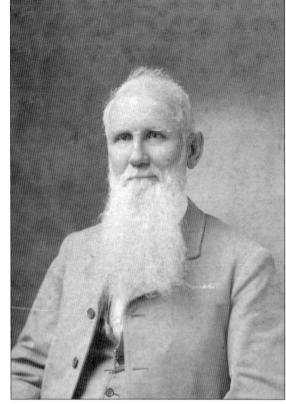

This photograph shows both Edward Goree's leg brace and his crutch. "Uncle Ed," as he was affectionately known by prison employees, used his horse Tina and a buggy to carry out his various duties. (Courtesy of the Thomason Room at Sam Houston State University.)

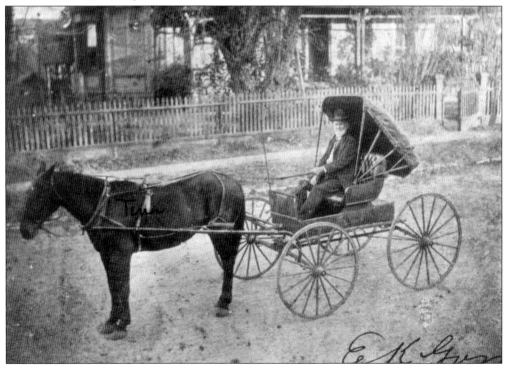

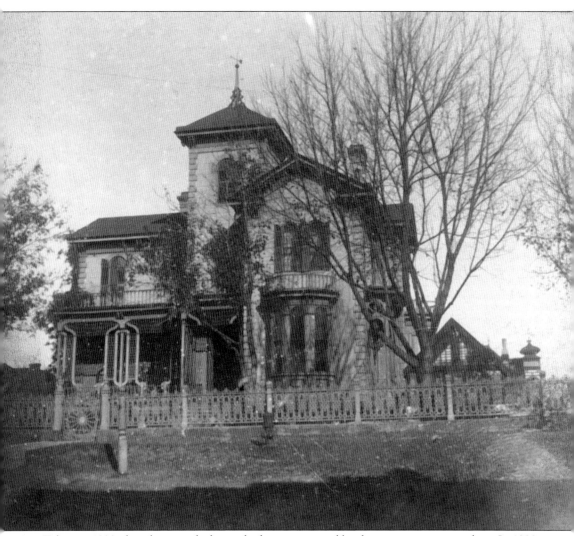

Taken in 1899, this photograph shows the home occupied by the prison superintendent. In 1899, Jonas Shearn Rice was the newly appointed superintendent of the prison system. In 1895, the former banker had begun serving as the financial agent for the penitentiary. After becoming superintendent, he remained in the position until April 1902. Jonas Rice was the nephew of William Marsh Rice, the millionaire philanthropist whose fortune founded Rice University in 1912.

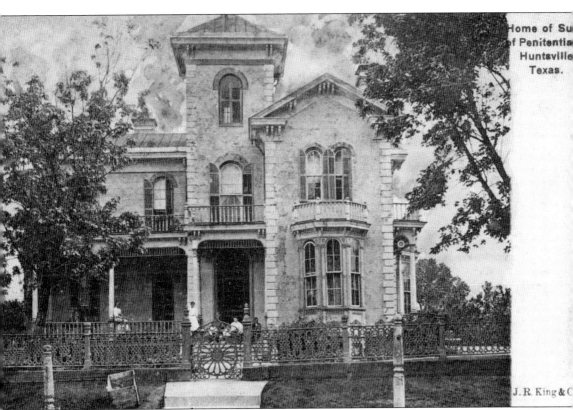

Home of Su
f Penitentia
Huntsville
Texas.

J. R. King & C

The house is seen again in this c. 1910 postcard. It is likely that this is the family of J.A. Herring, who served as superintendent during what was a particularly difficult period for the prison system. The Texas State Legislature conducted a sweeping investigation into numerous abuses—both physical abuse of convicts and financial abuse by various employees. Robert Underwood served as Herring's second in command as assistant superintendent of the prison system before becoming the warden of the Huntsville Unit.

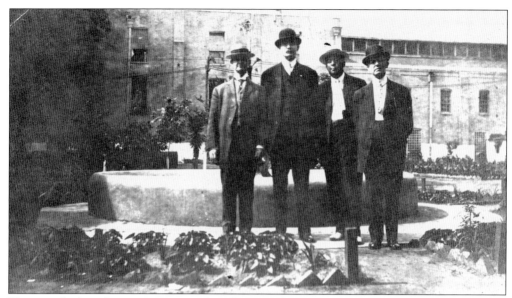

Photographed in the prison courtyard, in front of the hospital, Dr. Leonard H. Bush (far left) served as the prison doctor. Before he was promoted to head prison physician, Bush began his career traveling to the many prison farms to check on inmate health. He died in 1941 at the age of 75. (Courtesy of the Thomason Room at Sam Houston State University.)

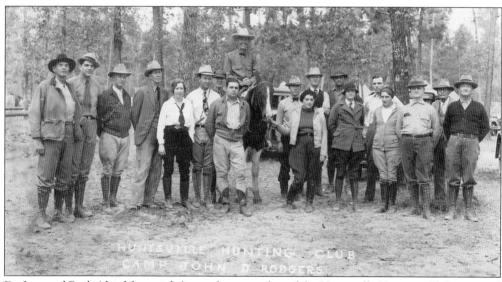

Dr. Leonard Bush (third from right) was also a member of the Huntsville Hunting Club, pictured here in 1932. Another prison official, Lee Simmons, stands fourth from the left. (Courtesy of Richard Nolan Pickett.)

Richard L. Winfrey was the chairman of the Board of Prison Commissioners beginning in 1919. He served as the police and fire chief and as a city commissioner in Dallas before being appointed to the board by Gov. William Pettus Hobby and moving with his family to Huntsville.

This photograph is of Elmer Gibbs, a friend of Richard Winfrey's daughter Dorothy, standing in front of the ornate wrought-iron gate at the superintendent's house around 1919. Gibb's father, Henry, worked as a clerk at the family general store, Gibbs Brothers, one of the oldest businesses in Huntsville.

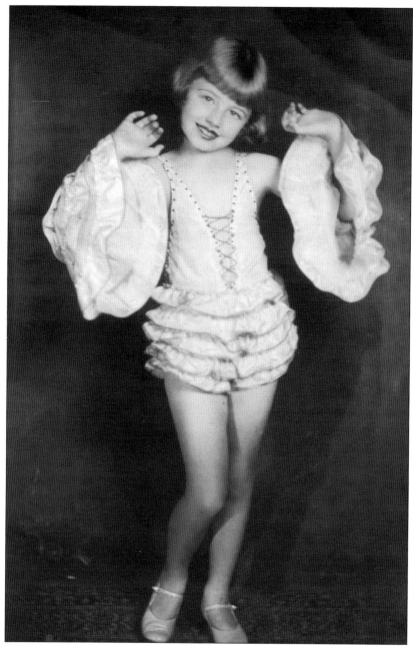

Young Dorothy Winfrey performed dances for the convicts at Huntsville, earning the admiration of a convict named Cooper Nail in May 1919. Addressing her as "Dear Little Friend," Nail wrote the child, "In trying to find something I could compare to your gracefulness while dancing, I . . . am sending you the most beautiful and graceful thing I have been able to capture. BUTTERFLIES!" Dorothy sent a letter to Gov. William Hobby asking him to pardon Nail, which he did. Cooper Nail, inmate No. 42800, was pardoned on August 19, 1919, after serving a little over one year in prison. In March 1920, however, he returned to Huntsville as inmate No. 44597. After serving 15 months of his two-year sentence, Nail was released again, and in 1932, Gov. Ross Sterling granted him full restoration of citizenship and suffrage.

Picket guard Henderson Howard is photographed at his post by Dorothy Winfrey around 1919. Pickets were located around the penitentiary to prevent escapes and protect the prison.

Two young boys play in the front yard of a prison official's home. The prison can be seen behind them. (Courtesy of the Thomason Room at Sam Houston State University.)

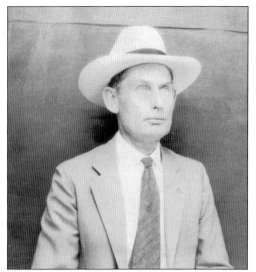

Norman L. Speer served as warden in Huntsville from 1924 to 1928. There are reports of his nieces dancing the Charleston when entertainer Jack Rimaro and his orchestra played on the prison chapel stage in the summer of 1927.

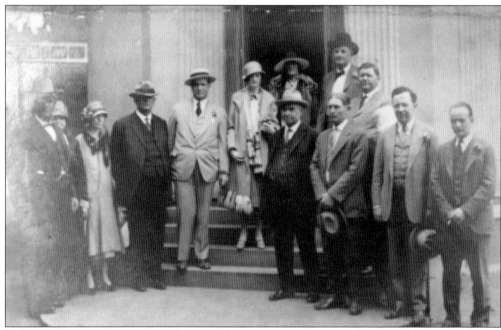

Miriam Ferguson visited the prison after she became governor of Texas in 1925. She is pictured here with various prison officials, including Warden Norman L. Speer (first row, third from right), and local dignitaries. The group is standing in front of the newly created library, built on the site of the former bandstand. Wearing a wide-brimmed hat, Governor Ferguson is framed by the doorway. Her husband, James Ferguson, stands to the right, towering over the others in a dark hat and bow tie. He was a former governor who was banned from running for public office after a series of scandals. Miriam, or "Ma" Ferguson, as she was known, was the first female governor of Texas and served two nonconsecutive terms. She made prison reform a priority of her administration and criticized her predecessor, Pat Neff, for not issuing enough pardons to inmates. This, she argued, led to a lack of discipline, as inmates had nothing to gain from good behavior. Like her Prohibition-opposed husband, Ma said she would readily pardon men arrested for liquor violations, thus reducing prison expenditures.

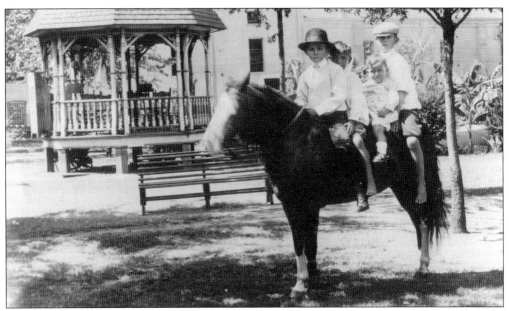

Four children of the Russell family enjoy a pony ride near the gazebo in the prison courtyard. (Courtesy of the Robert Russell Collection at the Texas Prison Museum.)

Lee Simmons, general manager of Texas prisons from 1930 to 1935, is pictured with his wife, Nola (right), and daughters in front of the director's home, known as "the mansion."

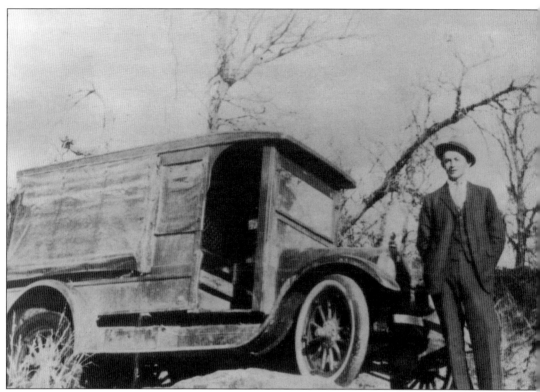

This photograph shows a 1925 version of the transfer wagon. Bud Russell served as the assistant transfer agent for the penitentiary from 1905 to 1914, and then as chief transfer officer from 1914 to 1944. He picked up thousands of convicts from county jails and brought them to Huntsville to be processed. Russell transported the newly convicted men under heavy guard. Submachine guns, brass knuckles, and a blackjack were among Bud's arsenal. Although the transfer process offered perhaps the best opportunity for a convict to escape, Russell only lost one prisoner during his career (he managed to shoot the escapee in the leg before he slipped into a large crowd at a religious revival). Russell was immortalized in song, including some versions of the song "Midnight Special," with lyrics including "Here come Bud Russell / How in the world do you know? / Well we know him by his wagon, and his forty-fo' / Big gun on his shoulder, big knife in his hand / He's comin' to carry you back to Sugarland." The final line is a reference to a prison farm located in Sugar Land, Texas. (Courtesy of Robert Russell Collection at the Texas Prison Museum.)

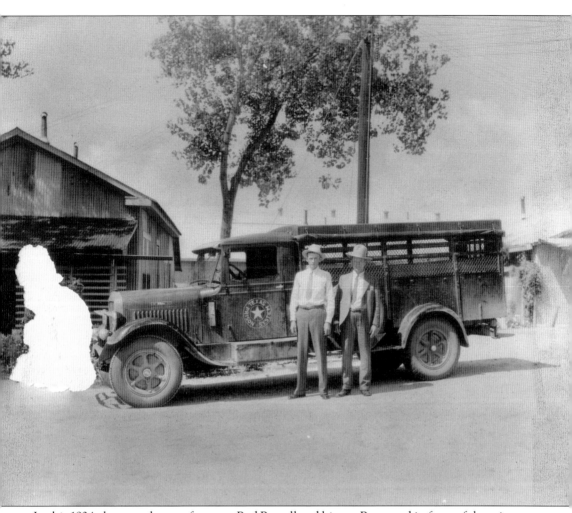

In this 1934 photograph, transfer agent Bud Russell and his son Roy stand in front of the prisoner transfer vehicle that held as many as 28 convicts. Over the years, the transfer vehicle changed. The transfer vehicle had several nicknames, including "Black Bettie," "Black Annie," and "Black Maria." (Courtesy of Robert Russell Collection at the Texas Prison Museum.)

Bud Russell stands in the lower yard at the Walls in 1934. (Courtesy of the Robert Russell Collection at the Texas Prison Museum.)

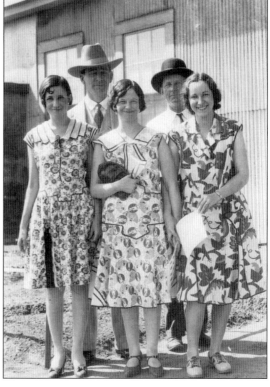

The three women in this photograph here were secretaries working at the administration building in the 1930s. Pictured are, from left to right, (first row) Ocie Cotton McDonald, Mattie Cotton Anders, and Eloyse Gammon; (second row) Warden Harrell and an unidentified man. Ocie and Mattie were the daughters of Warden Cotton. (Courtesy of Texas Prison Museum Archives/ Boehm Collection.)

Joe Byrd, one of the longest-serving assistant wardens at Huntsville, stands among the flower garden in the prison courtyard. Byrd loved the garden, which was kept lush and tidy by inmates. Byrd's grandchildren have fond memories of his love for flowers.

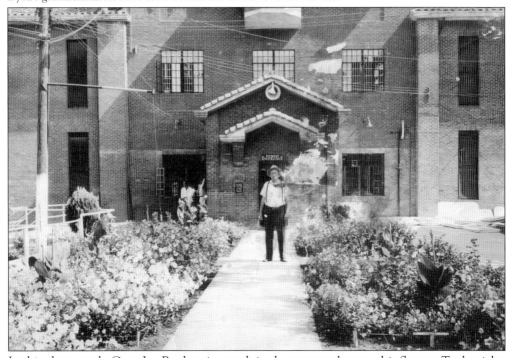

In this photograph, Capt. Joe Byrd again stands in the courtyard among his flowers. To the right, several mattresses have been placed outside the building to air out. To the left of the doorway, a group of inmates perform some upkeep.

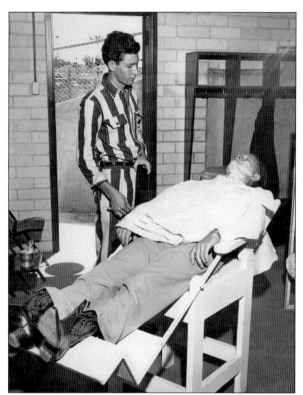

An inmate barber prepares to shave Pat Byrd. Byrd's father, Joe, worked at the prison for years, and Pat was the transfer agent in the 1950s. Considering that the convict is sharpening a large razor, Pat Byrd must have been quite trusting.

Joe Byrd stands next to the car owned by infamous Nazi Herman Goering. The custom-built Mercedes-Benz convertible was confiscated by the Army and brought to the United States following World War II. The car was part of a traveling exhibit and toured Huntsville on July 26, 1946. It was brought to the prison, and inmates were given a two-hour opportunity to examine the vehicle and learn the lesson that "even the mighty eventually come to grief."

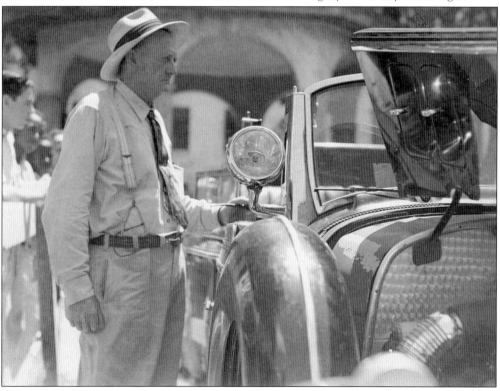

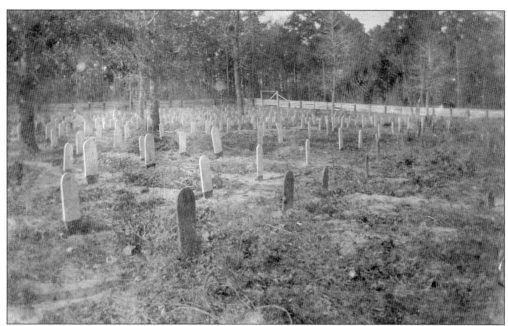

For years, convicts who died at the prison and were unclaimed by family were buried with little ceremony. Eventually, Joe Byrd decided that the convict cemetery deserved better treatment. He oversaw its restoration, and it is now named Joe Byrd Cemetery in his honor. Previously, locals had referred to it as "Peckerwood Hill." Before Byrd became involved, inmates were buried with only a marker listing their inmate number on a small headstone. Ironically, in the days of the electric chair, Byrd was also the executioner at Huntsville until his death in 1964. Above is an early image of the prison cemetery from 1899, and below is a photograph of the site shortly after it was renamed in honor of Captain Byrd.

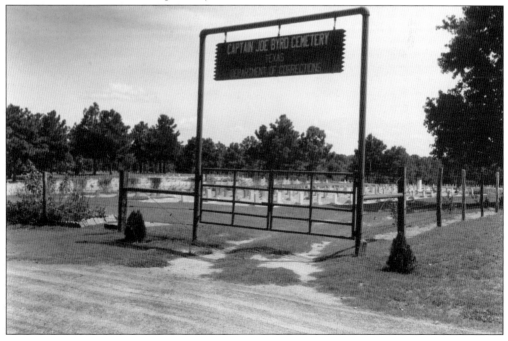

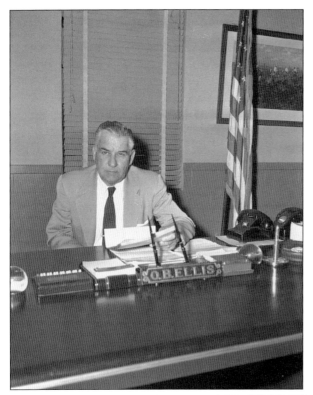

Oscar B. Ellis served as prison director from 1948 to 1962. Shown here in his office, Ellis was responsible for a period of reform in the prison system. When Gov. Beauford Jester took office in 1947, he was determined to improve the prison system in Texas, and Ellis was the man for the job. His reforms included a merit reward system to encourage good behavior, pay raises and better training for guards, and the updating and improvement the Walls.

William "Jim" Estelle Jr. was the director of the Texas Department of Corrections from 1972 to 1983. He is pictured walking through the bullring at the Walls. Before coming to Texas, Estelle worked 18 years for the California Department of Corrections. Today, there is a unit named after him in Walker County that holds elderly inmates and also has a "supermax" (high-security) unit.

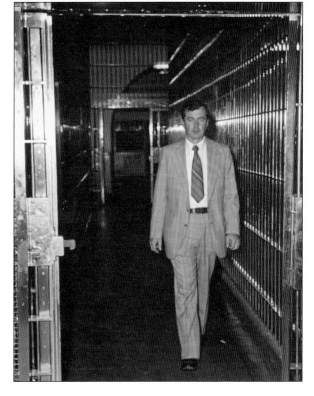

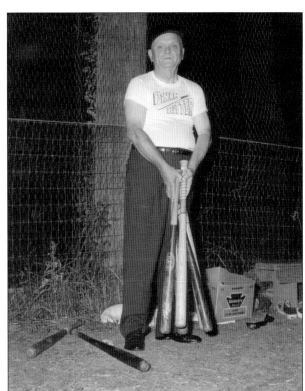

Right, Warden Emmett Moore is choosing a bat for a baseball game with the guards, pictured below.

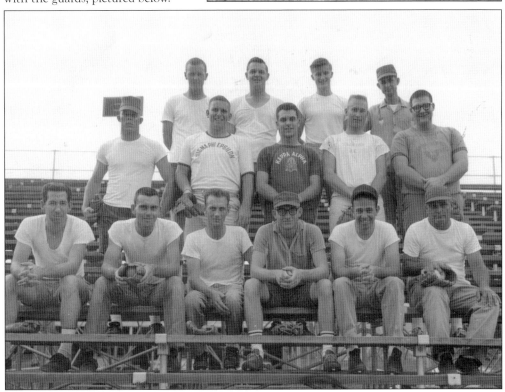

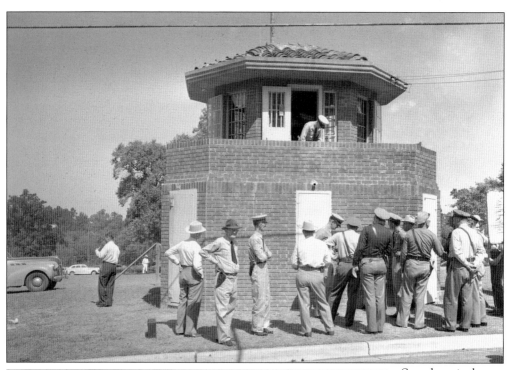

Seen here is the armory, where weapons are secured and, if the need arises, given out to guards.

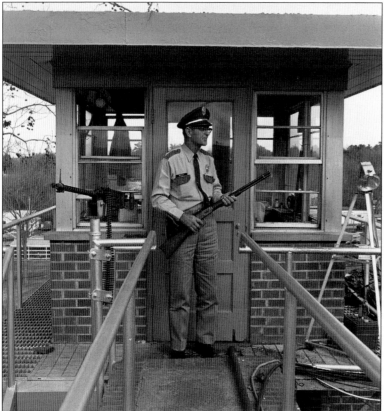

A picket guard watches the wall in the 1960s.

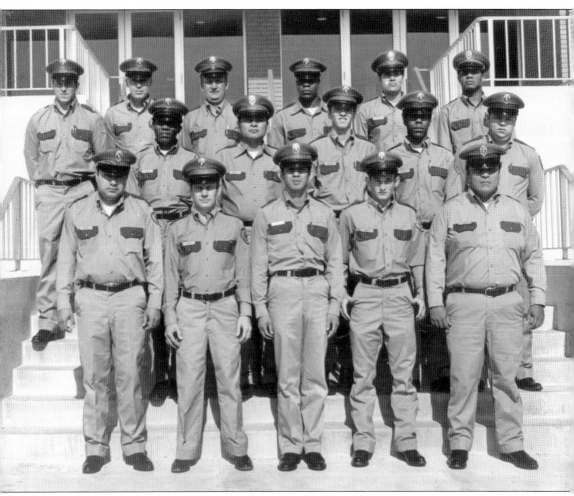

A class of newly graduated prison guards poses at the prison in May 1977. The prison is one of the most important employers in Huntsville, and in many cases, guards come from families that have seen several generations work at the Walls.

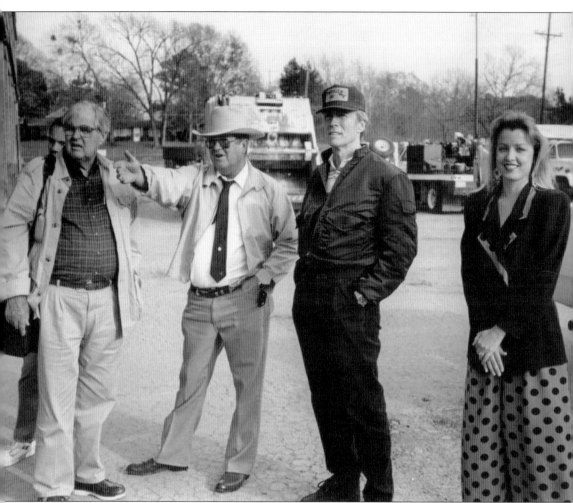

In this photograph from the early 1990s, Warden Jack Pursley (second from the left) gives actor Clint Eastwood a tour of the Huntsville Unit. In 1993, the Eastwood-directed film *A Perfect Word*, set in 1963, starred Kevin Costner as a fictional Huntsville escapee. In 1983, Pursley allowed another film crew to shoot a scene on death row and in the death chamber. In that movie, *Lethal Injection*, guards played themselves in the scene, and Pursley gave the actor portraying the warden some advice on how a real warden would behave. The low-budget film was never released to a wide audience. Pursley served as warden of the Huntsville Unit from 1978 to 1993, and between 1982 and 1993 the facility saw 71 executions.

Three

INFAMOUS INMATES

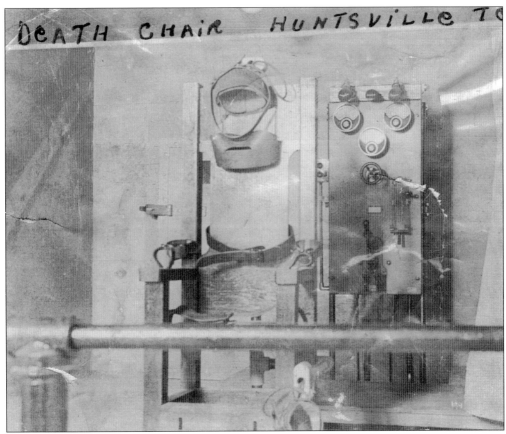

The electric chair, nicknamed "Old Sparky," came into use in 1924 after the State of Texas moved all executions to the Huntsville Unit. The first five executions all took place on the same day, February 8. Convicted murderer Charles Reynolds from Red River County was the first inmate executed in the electric chair in Texas. From 1925 to 1938, Texas executed four pairs of brothers in the electric chair—the Noel brothers on July 3, 1925; the Robins brothers on April 6, 1926; Oscar and Mack Brown on July 1, 1936; and Roscoe and Henderson Brown on May 6, 1938.

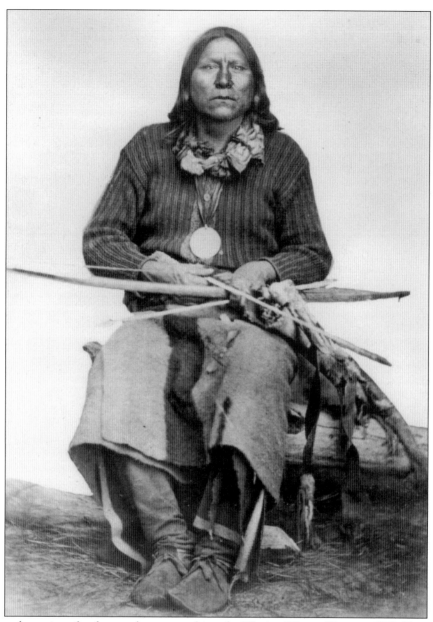

Sentenced to prison for the murderous attack on the Warren Wagon Train in 1871, Kiowa chief Satanta, also known as "White Bear," was one of the first Native Americans to be tried by the US government. He was paroled from Huntsville in 1873 after Pres. Ulysses S. Grant pressured Gov. Edmund Davis to parole the chief in hopes of using Satanta's release as a bargaining chip to prevent the Kiowa from joining the Comanche in what would become the Red River War. Upon his release, Satanta promptly joined the war, and following the defeat of the Indian coalition, his parole was revoked and he was returned to Huntsville. In 1878, prison guards claimed that he committed suicide by jumping out of a window on the top floor of the facility. He was buried at the prison, and his body remained there until 1963. (Courtesy of the National Archives and Records Administration, from William S. Soule Photographs of Arapaho, Cheyenna, Kiowa, Comanche, and Apache Indians, 1868–1875.)

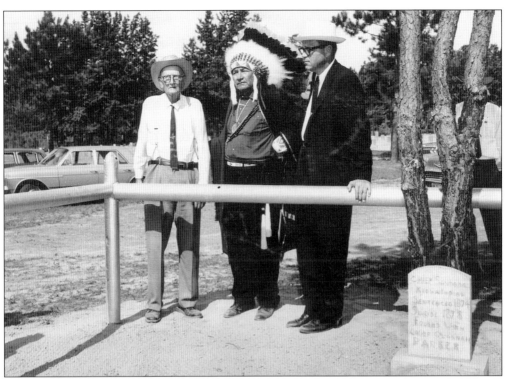

In this 1963 photograph, a descendant of Kiowa chief Satanta stands at the Walls Unit with Capt. Joe Byrd (left) and George Beto. The body of Satanta was reinterred on tribal land in Oklahoma.

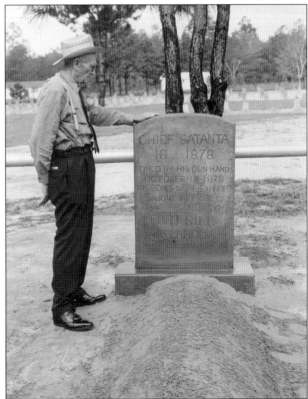

Captain Byrd stands beside the large monument to Satanta at the prison cemetery.

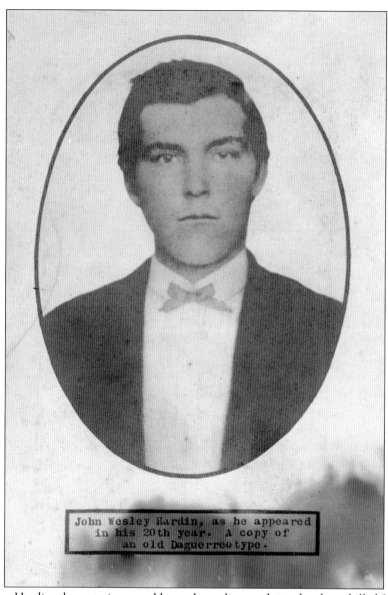

John Wesley Hardin, as he appeared in his 20th year. A copy of an old Daguerreotype.

John Wesley Hardin, the notorious gambler and gunslinger, claimed to have killed 24 men. He committed his first murder in 1868 at the age of 15, escaped from the Gonzales County jail in 1872, and killed a deputy sheriff in 1873. He was finally arrested in 1877 by Texas Rangers and, convicted of the murder of two men, was sentenced to 25 years in prison. After losing his appeal, Hardin arrived in Huntsville as prisoner No. 7109 in October 1878. While incarcerated, he worked in the wheelwright, carpentry, shoe, and tailor shops at the prison. After numerous attempted escapes, Hardin claimed to begin a course of "self-improvement" in 1885, in hopes of earning a pardon. He taught Sunday school and studied law. After serving 15 years and 5 months, Hardin was released from the Walls in 1894 and, a month later, he received a pardon from Gov. James Hogg. Although he became a practicing attorney, he drifted around Texas, drinking, gambling, and fighting. In August 1895, Hardin was shot and killed while gambling in a saloon. (Courtesy of Southwestern Writers Collection Texas State University - Alkek Library, the Wittliff Collections, John Wesley Hardin Papers).

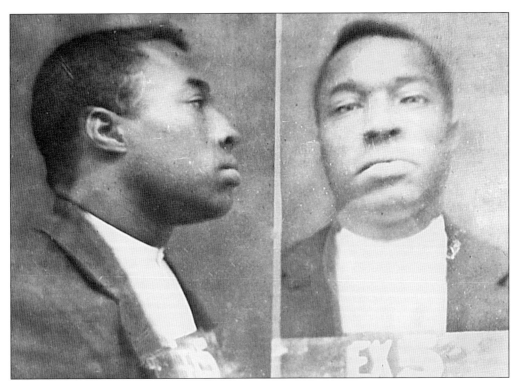

The mug shots of Charles Reynolds (above) and Mack Matthews (below) are seen here. Both men were executed in the electric chair on February 8, 1924, with Reynolds's being the first such execution in the state of Texas.

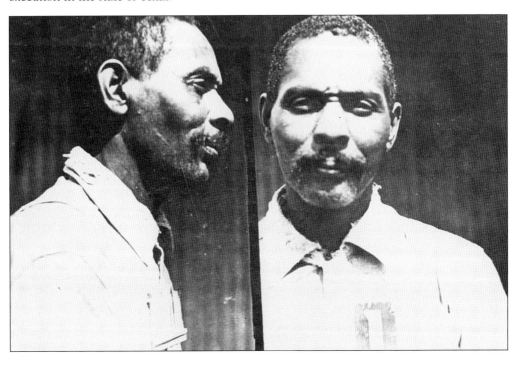

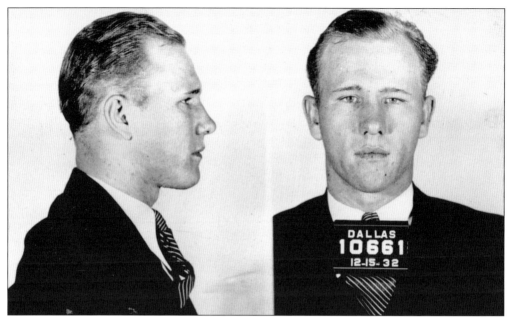

Pictured here are two members of the infamous Clyde Barrow and Bonnie Parker gang during the Depression. Raymond Hamilton (above) and Joe Palmer (below) had been incarcerated at the Eastham Prison Farm, located in Walker County, just north of Huntsville. With help from Bonnie and Clyde, who hid guns near the farm's field, Hamilton, Palmer, and two others escaped. Palmer shot and killed Maj. Joe Crawson, a prison officer guarding the inmates in the field. Shortly after Bonnie and Clyde were gunned down in Louisiana, Hamilton was captured and delivered to Huntsville. Palmer was captured soon after, and both men were sentenced to death in the electric chair for the murder of Crawson.

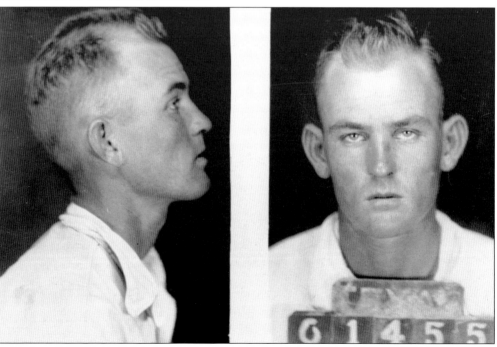

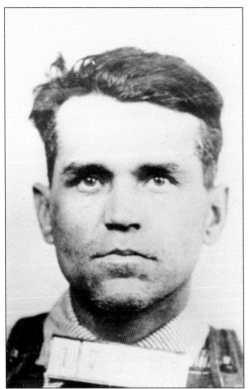

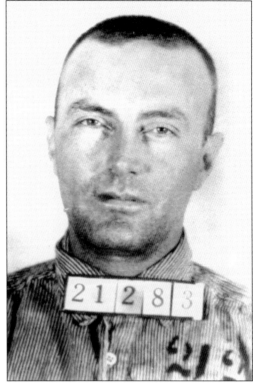

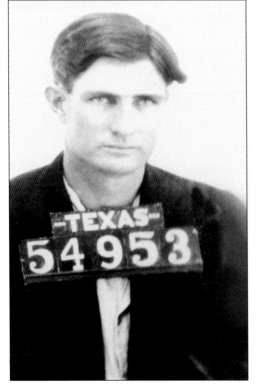

While awaiting execution, Hamilton, Palmer, and two other men on death row—Blackie Thompson (top left) and Charlie Frazier (bottom left)—plotted an escape. Whitey Walker (top right), Thompson's former partner in crime, smuggled guns into the prison through an unscrupulous prison guard, who gave them to Frazier. Frazier locked up the guards and released the men from their cells. Using a ladder, the inmates tried to make their way over the wall. Frazier was stopped, Walker was shot and killed, but Palmer and Hamilton successfully escaped, at least temporarily. Palmer was recaptured in Kentucky, and Hamilton, in Fort Worth, Texas. Both were executed on May 10, 1935.

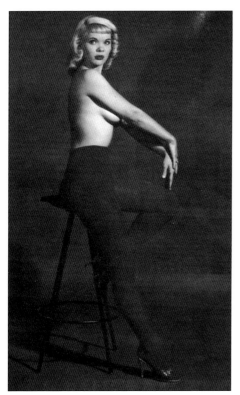

Juanita Dale Slusher—or "Candy Barr," as she was known—was a famous stripper in the Dallas area and a Huntsville inmate from December 1959 to April 1963. In 1957, she had been arrested for killing her second husband after he threatened her. The Grand Jury did not indict her on those charges. She was convicted of possession of marijuana after police found the drug hidden inside her bra and was sentenced to 15 years. She was the most well-known person arrested under Texas's tough new drug laws, and her arrest garnered much attention. The Dallas police reportedly used an illegal wiretap to catch her. During her appeal, she dated known mobster Mickey Cohen. Both prior to her arrest and after her release in April 1963, she was often seen around Dallas with bar owner Jack Ruby, who later killed Lee Harvey Oswald the day after Oswald assassinated Pres. John F. Kennedy. The image on the left is from a postcard advertising her show in Las Vegas, and below is her mug shot from the Texas Department of Corrections.

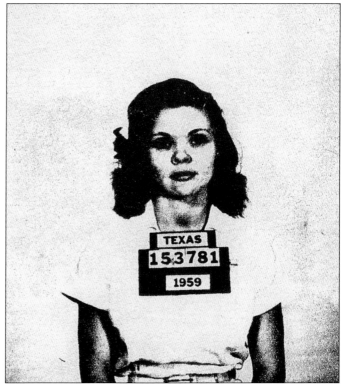

Many former prisoners felt compelled to write about their experiences in prison. Some wanted their story to serve as cautionary tales; others used these pamphlets to criticize the system and proclaim their innocence. Beecher Deason's writing laments his seven-year incarceration in the 1920s. He complained that inmates were made to work in all conditions, even while ill. In this 1939 pamphlet, Bill Mills describes his time incarcerated in several states, including five years in Texas in the 1910s. Mills recalled prison transfer agent Bud Russell and the neck chain that connected the inmates together. He described Huntsville was "Hell on earth." Neither Mills nor Deason were model prisoners. Both reoffended several times, and both were punished for various infractions while in prison. (From the author's collection.)

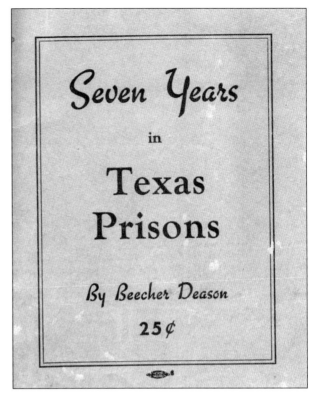

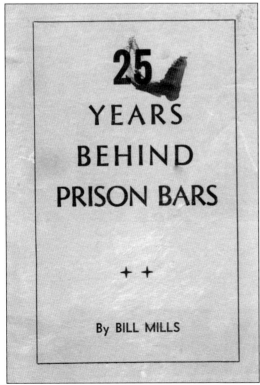

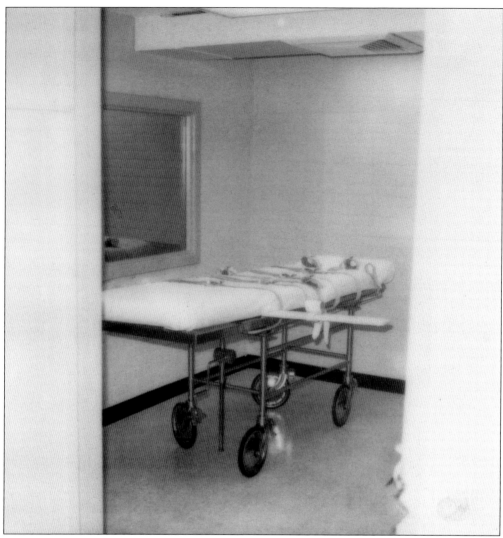

The lethal injection room is pictured here. Texas, along with the rest of the country, halted executions in 1972 as mandated by the Supreme Court. When the court lifted the ban on the death penalty in 1976, Texas replaced the electric chair with a new form of execution. Lethal injection was designed as a more humane way of ending a condemned person's life. The first inmate executed by lethal injection in Texas (and in the United States) was Charlie Brooks Jr. The current protocol for lethal injection in Texas involves the use of a single drug, pentobarbital.

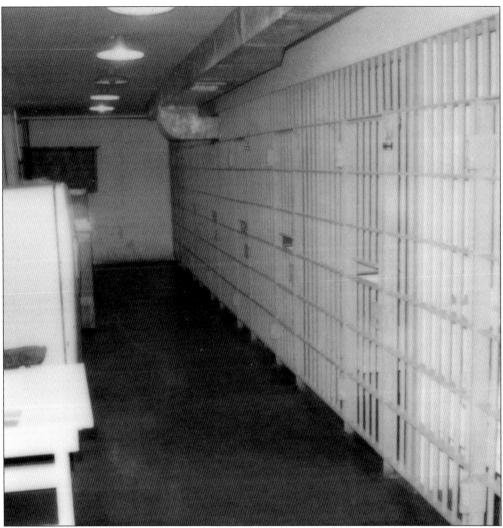

These are the cells of inmates on death row. Huntsville's death row was housed in the East Building until 1952; today, male inmates on death row are held in the Polunsky Unit in Polk County. They are housed in individual cells, and some have access to a radio. Female death row inmates are housed at the Mountain View Unit in Gatesville. All are transferred to Huntsville for their executions.

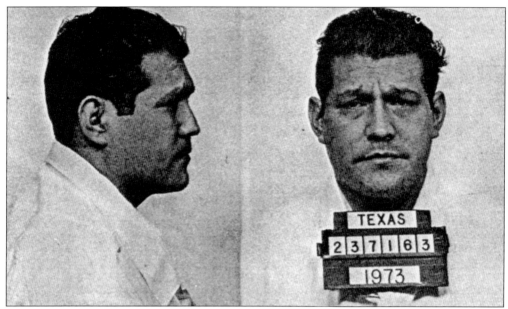

Frederico Gomez Carrasco was a violent convicted drug dealer who perpetrated an attempted escape from the Walls that led to the longest prison siege in US history. Born in San Antonio in 1940, Carrasco led a cocaine and heroine trafficking empire in Texas, California, and Mexico, and even had associates selling drugs for him in Chicago. His violent acts included perhaps as many as 47 murders, committed both by him and by dozens of others at his behest. He committed his first murder at the age of 18. Carrasco was arrested in 1972 in Mexico with more than $100 million in heroine and hundreds of weapons. He was able to escape authorities after offering bribes and returned to Texas to seek revenge on gang members that he believed to be involved in his arrest. In July 1973, he was taken into custody after a shoot-out with police in San Antonio. After being convicted of the attempted murder of a police officer, Carrasco was sent to Huntsville with a life sentence.

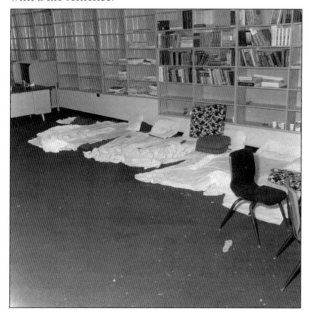

On July 24, 1974, Carrasco and fellow inmates Ignacio Cuevas and Rudolfo Dominguez, having managed to get weapons smuggled into the prison, barricaded themselves and 15 hostages in the third-floor library. Their plan was to use the hostages—11 of whom were civilian employees—to negotiate their own escape from the Walls. This photograph of the library was taken after the siege.

Warden "Hal" Husbands was in his office when the hostages were taken and guards were fired upon. He immediately notified outside authorities and began attempts to negotiate the release of the hostages. Husbands worked for the Texas prison system for years and had been warden in Huntsville for less than one year when the siege began. He helped negotiate the release of one of the hostages, who provided valuable information about what was happening inside the library. Prior to his career with the Texas Department of Corrections, Husbands had been a football player at Rice University and had played in the 1938 Cotton Bowl. He had also previously been the warden of the Central Prison Farm in Sugar Land. The two-time "Warden of the Year" retired four years after the Carrasco siege. (Courtesy of Robert Husbands.)

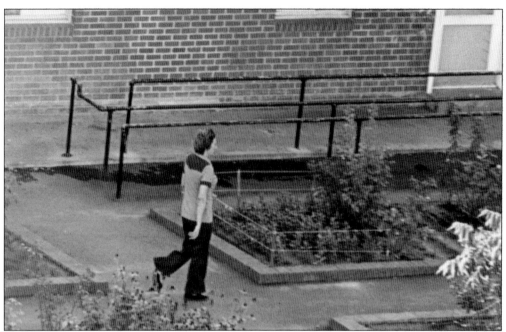

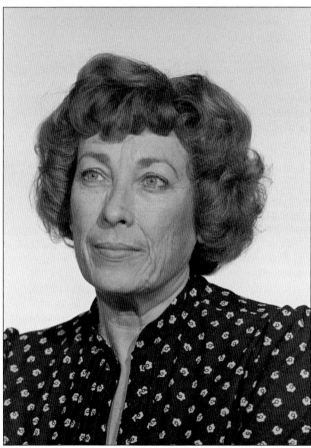

After several days, one of the hostages, Glenn Johnson, suffered a heart attack and was released. One of the female hostages, Aline House, then faked a heart attack and was also let out of the library. Inmate hostage Henry Escamilla made a desperate escape, jumping through the glass doors of the library. He was severely cut, but he had escaped. In this photograph, hostage Linda Woodman flees across the courtyard after being sent with a message from Carrasco.

Linda Woodman is pictured here in her official portrait as warden of the women's prison in Gatesville. Although she had only worked for the prison a few short weeks before being taken hostage by Carrasco, she remained with the prison and, within a year, worked her way up to warden. Woodman also became the first woman to direct a male inmate crew, in 1979. She passed away in January 2011.

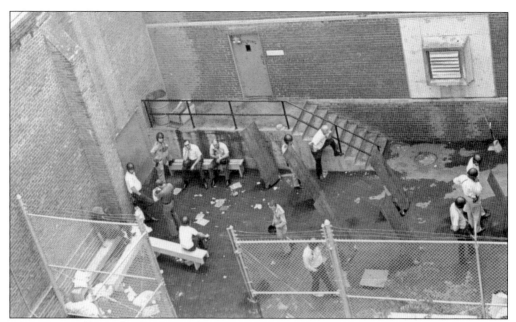

W.J. "Jim" Estelle Jr., the director of the Texas Department of Corrections at the time of the siege, was joined in his efforts to secure the release of the hostages by the Federal Bureau of Investigation, the Texas Department of Public Safety, and the Texas Rangers. The 11-day standoff became a media sensation, with reporters from across the country reporting around the clock. The prison was on lockdown, and guards stayed at the prison the entire time. In the photograph shown here, off-duty guards wait outside during the siege.

Shown here a few years before the siege, Fr. Joseph O'Brien was the prison chaplain. Father O'Brien was wounded during the Carrasco siege after volunteering to act as a go-between to try to facilitate a resolution. After carrying messages back and forth on the first day, Father O'Brien was taken hostage with the rest on the second day.

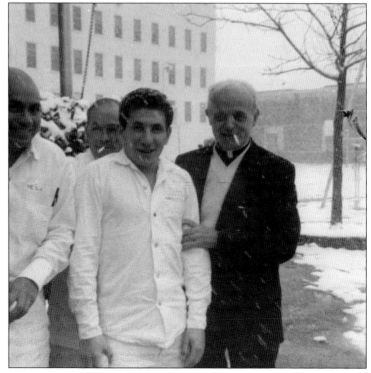

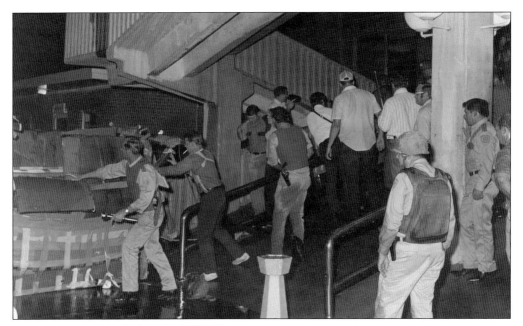

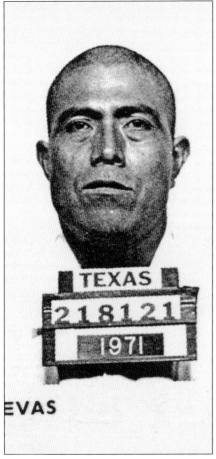

On August 3, 1974, Carrasco, Cuevas, and Dominguez decided to make an attempt at escape. They had demanded an armored car and Gov. Dolph Briscoe authorized it. Carrasco forced the hostages to create a shield out of rolling blackboards with books secured to them. Called the "Trojan Taco" by the media, the men's plan involved standing inside this contraption with hostages acting as a shield. They handcuffed themselves to the remaining female hostages and put Father O'Brien inside as well. The remaining hostages encircled the so-called Taco and began rolling it out of the library. There were four ramps leading down from the library, and hostages would need to maneuver around four turns before reaching the bottom. When they got to the last ramp leading out of the building, the Texas Rangers began spraying them with fire hoses. The shield and hostages began to topple. Unfortunately, there was a temporary problem with the hoses and Carrasco and his accomplices were able to right themselves. Carrasco then shot and killed the woman handcuffed to him, Elizabeth Beseda. Julie Standley, handcuffed to Dominguez was also shot and killed. Father O'Brien was shot, but he survived. Officials opened fire and killed Dominguez. Carrasco shot himself, and Cuevas, uninjured, was taken back into custody. Cuevas, left, would pay the price for the siege. Convicted and sentenced to death for his part in the hostages' deaths, he was executed on May 23, 1991. In the photograph above, officers stand on the wet ramp after the siege ended. The "Trojan Taco" is on the left in the image.

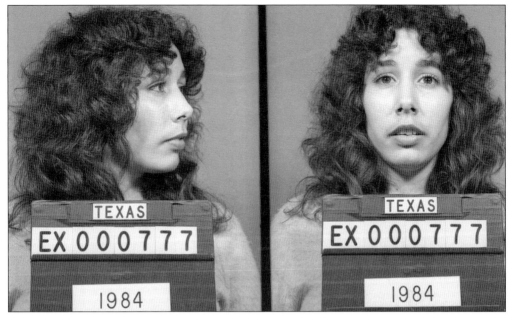

The first woman executed in Texas since 1863, Karla Faye Tucker spent 14 years on death row. Tucker was using drugs when she helped her boyfriend, Danny Garrett, rob and kill Jerry Dean. After Garrett attacked the victim with a hammer, Tucker attacked him with a pickaxe. She then discovered Deborah Thornton hiding in the apartment and killed her with the pickaxe as well. Both Tucker and Garrett were convicted of murder. Tucker, though, claimed to have had a religious awakening and became a Christian. While Garrett died before he could be executed, Karla Faye Tucker became an international symbol for those who opposed the death penalty. Arguing that she never would have committed the murders had she not been under the influence of drugs and citing her reform as a born-again Christian, her legal team fought to spare her life. All of her appeals were denied, however, and she was executed on February 3, 1998, by lethal injection. Three women had been executed in Texas before Tucker. Jane Elkins, a slave, was executed in 1853 or 1854. Another slave, Lucy Dougherty, was hanged in 1858 for killing her mistress. "Chipita" Rodriguez was hanged in 1863 for robbing and murdering a man, but was posthumously pardoned by the Texas Legislature in 1985. Below, Karla Faye Tucker is seen being led to the death house shortly before her execution.

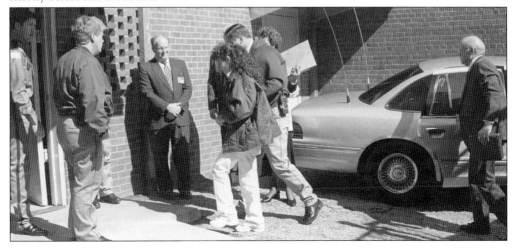

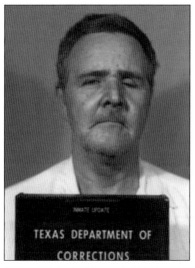

Convicted serial killer Henry Lee Lucas is seen in this 1990 inmate update photograph. Although he confessed to killing more than 600 people, Lucas was convicted of murdering 11 people in Texas in 1983. The State of Texas sentenced him to death for the murder of one unidentified woman. Although there is evidence that he killed people in Michigan and Texas, and possibly also in Florida, the Texas Board of Pardons and Parole determined that he likely did not kill the woman for whose murder he received his death sentence. In 1988, Texas governor George W. Bush commuted Lucas's death sentence to life in prison. Lucas died in Huntsville in March 2001.

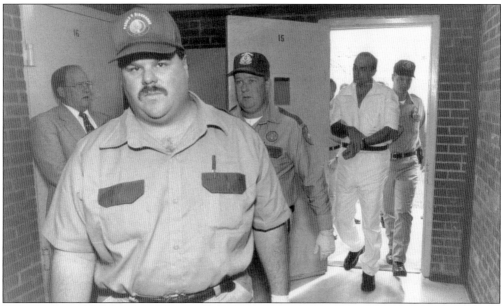

Convicted serial killer Kenneth McDuff is led to the death chamber in 1998. McDuff, who had a long history of criminal activity and had served several stints in prison, was suspected of at least 14 murders. In 1966, he and accomplice Roy Dale Green brutally killed three teenagers. McDuff was sentenced to death for those crimes, but his sentence was commuted to life in prison, which made him eligible for parole. Because of prison overcrowding, he was paroled in 1989, one of 20 former death row inmates released. He was out of prison for three days before he killed again. This murder went unsolved for a time. After a brief return to Huntsville for a parole violation, McDuff was back on the streets. After he murdered several women across the state, a warrant for his arrest was issued in March 1992. McDuff fled to Kansas, but when a coworker recognized him from the television program *America's Most Wanted*, Kansas City police were able to make an arrest and extradite him back to Texas. In February 1993, he was sentenced to death. After exhausting his appeals, Kenneth McDuff was executed in April 1998. Since no one wanted to claim his body, he is buried in the Captain Joe Byrd Cemetery beneath a headstone that lists only his inmate number and date of execution.

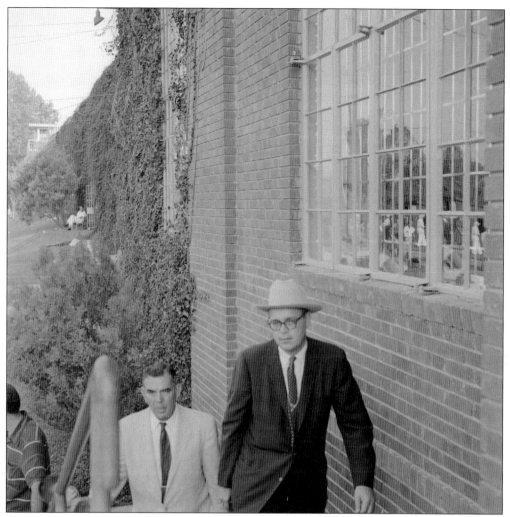

George Beto served as the director of the Texas Department of Corrections from 1961 to 1972. A former Lutheran minister, he served as president of Concordia Lutheran College in Austin from 1949 to 1959. He also held a doctorate in educational administration, and his belief in education would carry into his work for the prison system. He first served on the Texas Prison Board, where he pushed for improving education for inmates as a means of hopefully of cutting down on recidivism. Beto visited prisons throughout Europe to gain a better understanding of the educational needs of inmates. A firm believer that prisons should try to rehabilitate criminals, he was convinced that education was the solution. He also believed that honest labor would benefit inmates and, in order to provide new opportunities for prisoners to acquire job skills, pushed Gov. John Connally to require all state agencies to purchase needed items from the prisons. This practice also brought in much-needed revenue for the prison system. In 1969, Beto gained legislative approval for a public school district for all inmates in Texas prisons. The Windham School District did not have geographic boundaries like other school districts but encompassed all of the prisons in the state. Beto did have his detractors, and many inmates felt he was heavy handed in discipline. There were many inmate complaints during his tenure, including a dramatic and far-reaching class-action lawsuit filed by David Ruíz. Beto is pictured here, wearing his signature hat, as he enters the Walls. In the background, an inmate can be seen sitting outside an open door. Reflected in the glass on the right are inmates working in the yard.

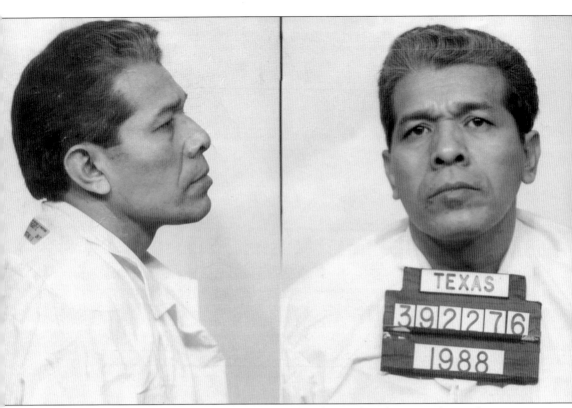

Pictured here is David Ruíz, the man behind a landmark case about living conditions for prisoners. The son of migrant farm workers, Ruíz had been in trouble with the law from the time he was a teenager. After serving a sentence in a juvenile facility, he eventually made his way to Huntsville and from there, to one of the state prison farms. He claimed he suffered various forms of mistreatment and abuse. He attempted to escape once, and tried to kill another inmate on another occasion. To avoid work in the prison fields, Ruíz cut his Achilles tendon. This was a tactic used by numerous inmates to avoid being sent to work on prison farms. After Lee Simmons took over as general manager in 1931, incidents of self-mutilation dropped dramatically. Ruíz did not manage to stay out of trouble in prison, and after a stint in solitary confinement, he became a prison activist. His case began as a petition, but quickly evolved into a class-action lawsuit, *Ruíz v. Estelle* (1980). Ruíz died in 2005 in prison.

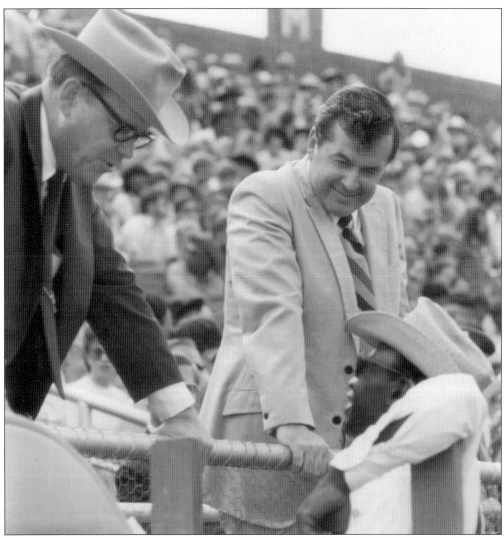

William J. Estelle, pictured on the right with George Beto at the prison rodeo, was the director of the Texas Department of Corrections and was therefore named in the lawsuit. Ruíz argued that the prison's overcrowding and harsh conditions amounted to "cruel and unusual punishment," which is banned under the United States Constitution. In 1979, he won in court, and in 1980 Federal District Court judge William Justice issued a report condemning the Texas prison system and demanding reform. One part of that order was that the state must keep the inmate population at 95 percent or less of the total prison capacity. This was to address a serious overcrowding problem that led to many inmates being housed in tents. The Federal District Court exercised oversight of the prison system until 2003. To comply with the ruling, the department of corrections cut back on the number of convicts transferred to state prisons from county jails and also increased the number of people put on probation. The most controversial part was the early-release program; so many inmates were released after serving only a small portion of their sentences that recidivism quickly rose. To cope with the increased number of inmates coming into the system during the "War on Drugs" in the 1980s, the Texas Department of Corrections began building more prison facilities.

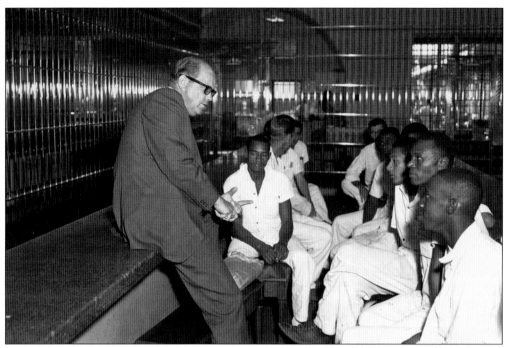

George Beto speaks with
newly arrived convicts
in the bullring.

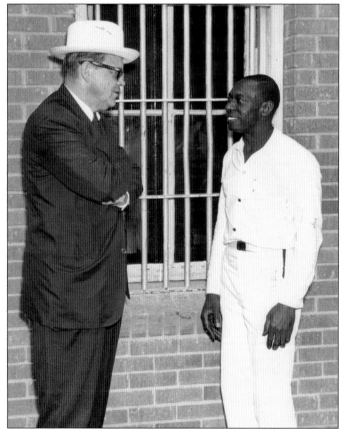

Beto gives some advice
to an inmate.

Four

CONVICT WORK

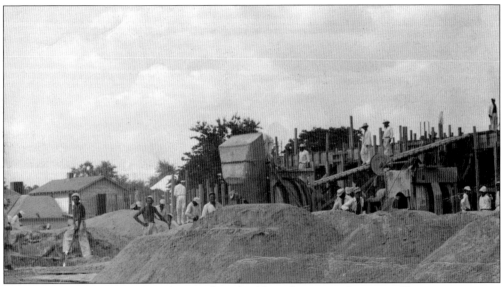

These inmates are pictured as they work on building the new rodeo arena. From its inception, Texas's first prison was designed to work convicts. When penitentiaries replaced Colonial-era punishments like public hangings and whippings, the hope was that they would serve as institutions of reform and rehabilitation, reshaping inmates into productive citizens. A key factor in the plan for rehabilitation was honest labor as a means to help instill a work ethic. That was the ideal put forward by the early proponents of the penitentiary. By the 1850s, though, when the Texas prison had more than just a few inmates, convict labor became more about offsetting operational costs and less about rehabilitation. The Texas Legislature authorized a $35,000 expenditure to build a textile mill at the Walls Unit in 1853. There, convicts manufactured both cotton and wool fabric. The lower-quality cotton found a market in the manufacture of slave clothing, and during the Civil War, the mill made fabric for Confederate uniforms. Once the prison earned a profit, the die was cast; the prison would continue to search for ways to not only cover prison expenses but also to bring much-needed money into the state treasury. During the convict lease era of 1871 to 1914, there were many years of profits. Increasingly during this period, the Walls Unit was reserved for white inmates serving long sentences. While African American inmates toiled on cotton and sugar plantations, white inmates in Huntsville performed a variety of labor, including the manufacture of fabric, wagon wheels, and furniture. Some inmates worked in the tailor shop. By the 1930s, work included a printing press, a license plate plant, and a cabinet shop. Inmate labor was utilized in expanding and repairing the prison, as exemplified in this image.

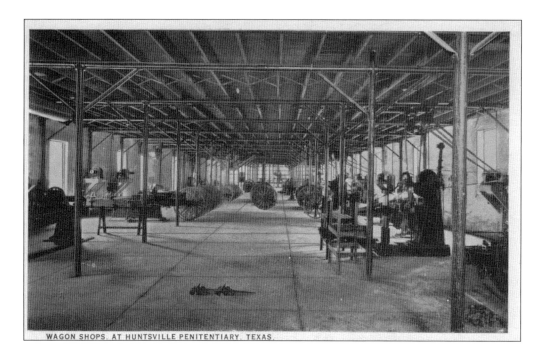

WAGON SHOPS. AT HUNTSVILLE PENITENTIARY, TEXAS.

The postcard above shows the interior of the wagon shop in 1939. Here, inmates manufactured wagons for use on prison properties and for sale to civilians. Below, a convict works on a wooden wagon wheel around 1940.

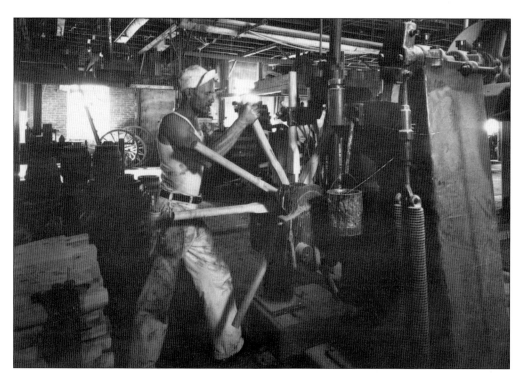

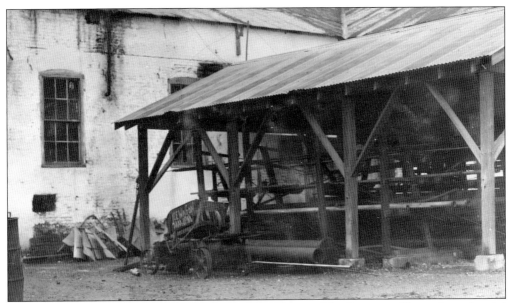

This is an interior view of the prison, showing a work area. The "lower yard" was the industrial section of the prison. The wagon near the shed is labeled as an ice wagon, and its wheels appear to be designed to move on rails. The area in the lower yard near the boiler was referred to as the "dummy." According to former inmate Bill Mills, prisoners would be sent there to cut wood. Mills said that it was called the "dummy" because one did not need to be intelligent to work there. Newly arrived inmates were often assigned work in this area.

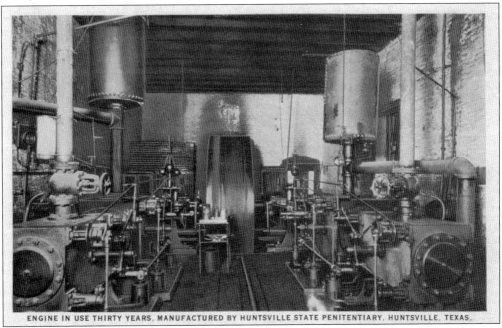

ENGINE IN USE THIRTY YEARS, MANUFACTURED BY HUNTSVILLE STATE PENITENTIARY, HUNTSVILLE, TEXAS.

The engine room had been in operation for 30 years at the time of this photograph, kept in working order by convict mechanics. In 1911, it and other portions of the Huntsville Unit were destroyed by fire. The engine room was quickly rebuilt, however, and this 1940 postcard is proof that the convicts did quality work.

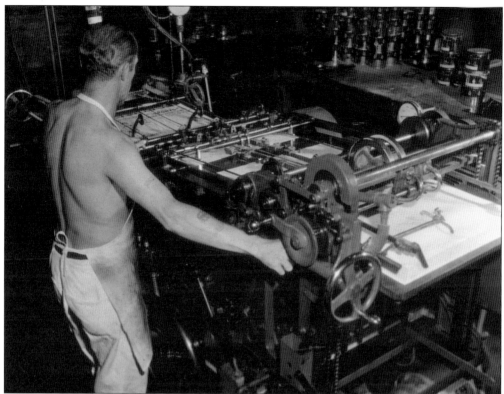

Above, an inmate operates a printing press for the prison's own newspaper, the *Echo*. Below is a 1940s view of the print shop. Inmate tasks included typesetting and proofreading.

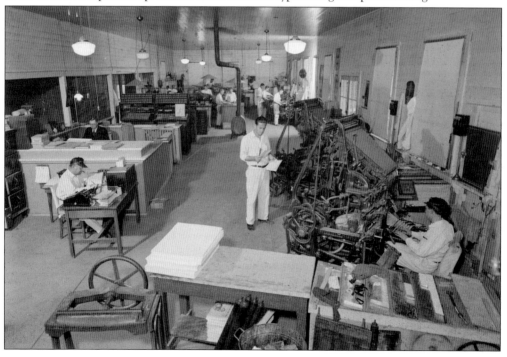

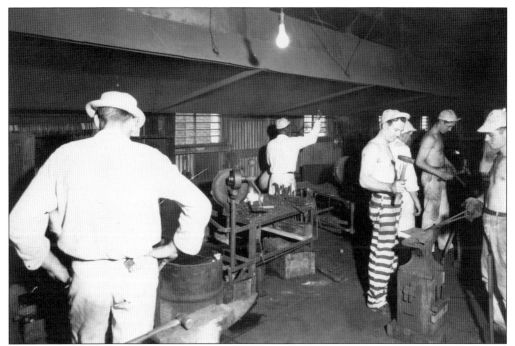

In the machine shop, inmates worked on various engines needed for the day-to-day operations of the prison. They repaired farm equipment, automobile engines, and a variety of mechanical equipment.

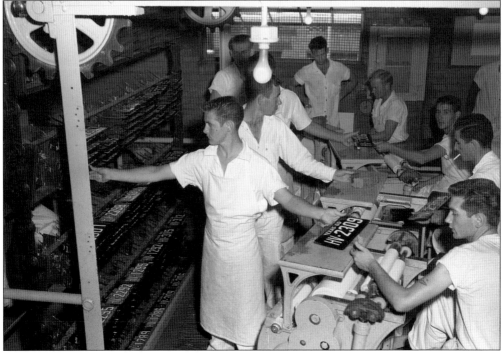

Like many other states, Texas used convicts to manufacture license plates. This photograph is from the 1960s.

In this 1937 photograph, the cotton warehouse is being expanded by convict workers. Cotton was an important crop grown on the multitude of prison farms owned by the state. Prison-grown cotton was shipped to the Walls to be sold, and the funds generated helped offset the costs of operating the prison system. By the 1930s, farming had lost some of the importance it had since the 1880s. At one time, the prison farms earned enough money to run the entire prison system without any appropriation of funds from the legislature.

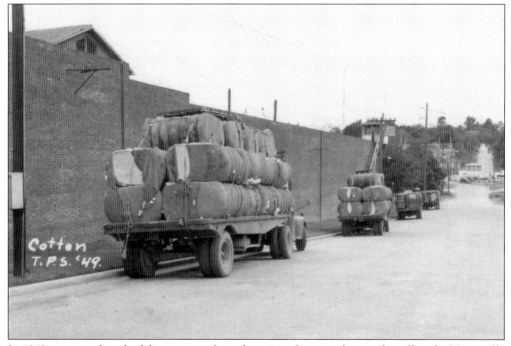

In 1949, a group of trucks deliver cotton from the prison farms to the textile mill at the Huntsville Unit. They are lined up outside the wall.

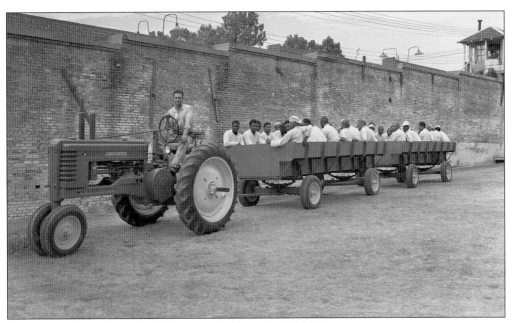

Inmates are driven from the Walls to work in nearby fields. The new transport wagons were part of a reform put in place by Oscar Ellis to end the practice of forcing inmates to run at a rapid pace to their work details.

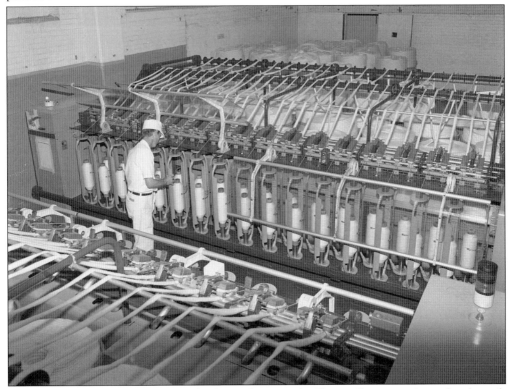

In the 1850s, the textile factory was the first industry in the Huntsville prison. An updated, much more modernized version is shown in this photograph.

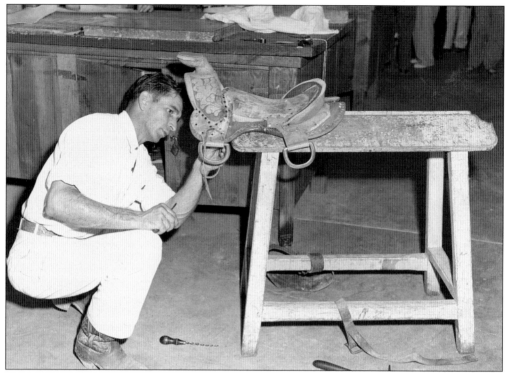

An inmate works on an ornate saddle in the 1940s. Leatherwork was a popular form of employment among the prisoners.

Guard Frank Roberts (center) was in charge of the plow-manufacturing workshop. He is seen here in 1938 with Otis Ferguson (right) and inmate Barney Mackley.

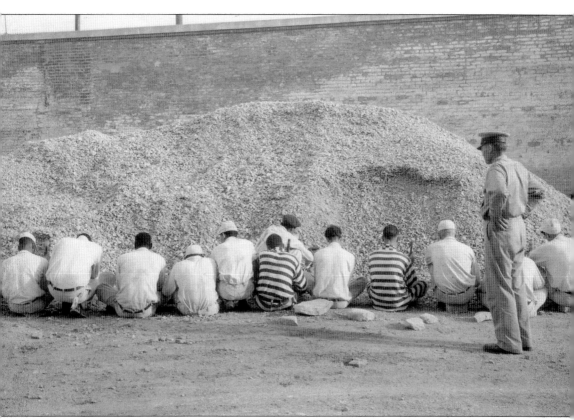

Convicts crush rock in front of the outside wall as a guard watches. This type of work was often assigned to new inmates or to those being punished. Hammers are visible in some of the inmates' hands.

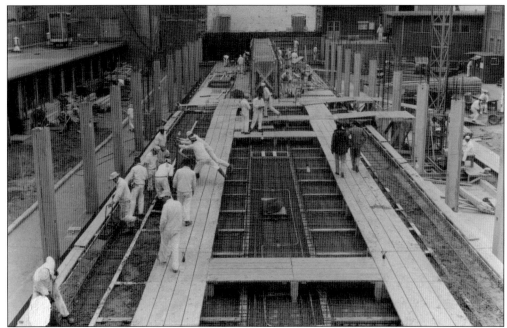

Convict labor was used to remodel the prison over the years. Pictured around 1958, these inmates are working on the new West Building. On the left is the Piddling Shop, where various craft works were located. The white building on the right is the prison hospital. In the center is the back of the administration building.

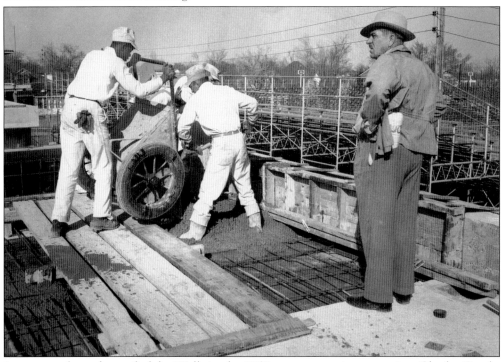

Inmates work on the roof of the Walls in the 1950s as construction supervisor Charles Combs looks on.

Five

CONVICT LEISURE

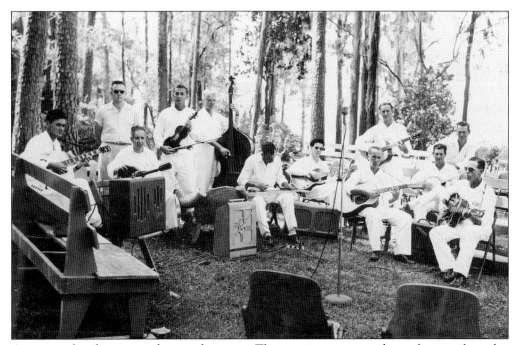

An inmate band warms up for a performance. The musicians are seated outside, near the rodeo arena, around a microphone and speakers. They play a variety of stringed instruments, including steel guitar, upright bass, violin, and acoustic guitar.

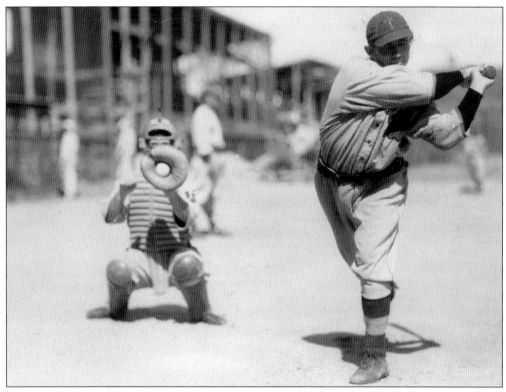

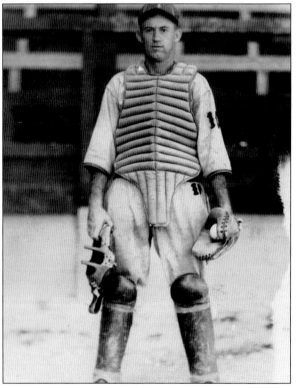

These two 1930s photographs show convict baseball players. Inmates with good behavior were allowed to participate in a variety of sports to boost morale. The baseball diamond was inside the walls, and the team, named the Tigers, played numerous semiprofessional baseball teams. These teams all traveled to Huntsville to play, and guards and local citizens enjoyed attending. The Tigers were playing against the Humble Oilers on July 22, 1934, when two members of the Barrow Gang staged a daring prison escape.

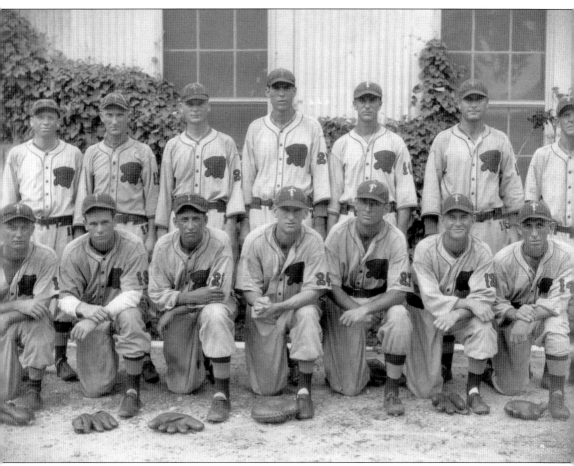

The Huntsville Tigers (pictured here in the 1920s or 1930s) consisted only of white men, while an alternate team, the Black Tigers, existed for African American inmates. The Black Tigers were showcased during Juneteenth festivities, a date that celebrated Texas slaves learning of their freedom.

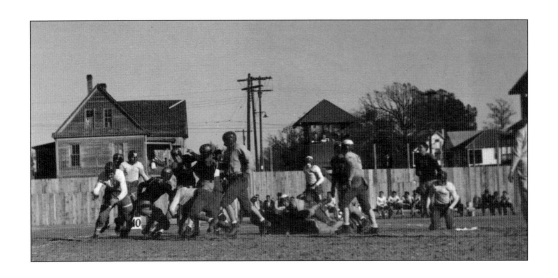

Football was another popular inmate sport. These photographs are from the late 1920s or the early 1930s. In the image above, note the guards in the picket tower in the center background; they had an excellent view of the game. In the photograph below, a convict player scores a touchdown. In both images, an African American convict can be seen in the background (above, seated to the far left; below, to the right of player No. 43). African American inmates did not participate in football during this period.

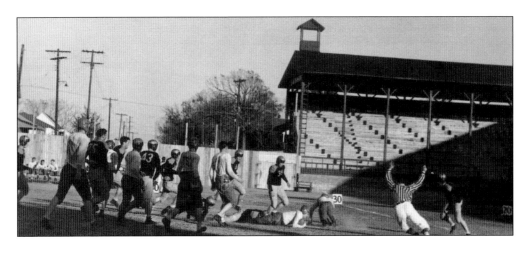

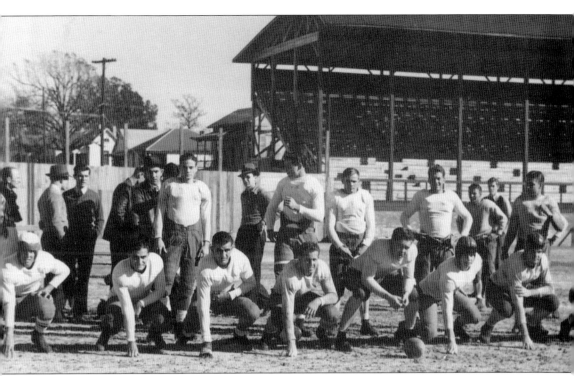

One of the inmate football teams poses here for a group photograph. Prison employees volunteered to act as coaches and referees.

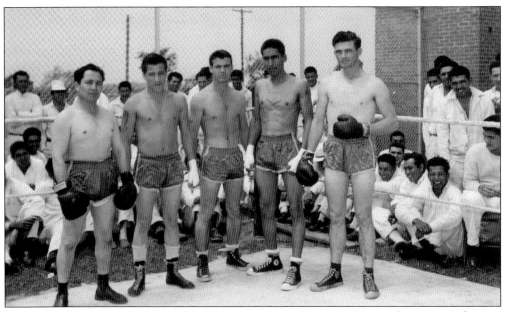

Boxing became another popular pastime for convicts. This photograph appears to be from the late 1950s or early 1960s. During the 1930s, matches were often scheduled for special events, such as the Fourth of July. Several of the bouts were written about in the prison newspaper, the *Echo*, which described violent fights that resulted in broken bones and knockouts. Until desegregation in the 1960s, most of the prison fights were confined to men of the same race. Prison officials believed that this was a healthy outlet for aggression and hoped it would prevent unregulated violence inside the Walls.

Inmates practice their boxing skills in the prison yard. The man to the left appears to be giving some pointers to two other inmates.

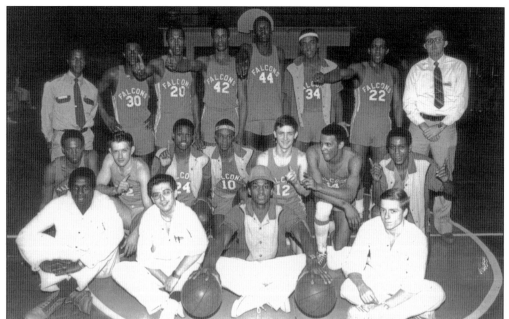

Robert Hayes (first row, far left) sits with the inmate basketball team at the Walls. Hayes, nicknamed "Bullet Bob," was an Olympic gold medal–winning sprinter and played for the Dallas Cowboys. Unfortunately, he was sent to Huntsville on a narcotics charge in 1979. He was released on parole in 1980 after serving 10 months of his five-year sentence.

Weighing 350 pounds with 21.5-inch biceps, Paul Wrenn was the 1981 world champion power lifter. His record-breaking 974.6-pound squat event made him a celebrity in the power-lifting world. Wrenn also held a master's degree in divinity and used his power-lifting skills to help spread his missionary message to inmates. During a visit to the Walls Unit, Wrenn performed his usual routine and ended by lifting the largest person in the audience with his teeth.

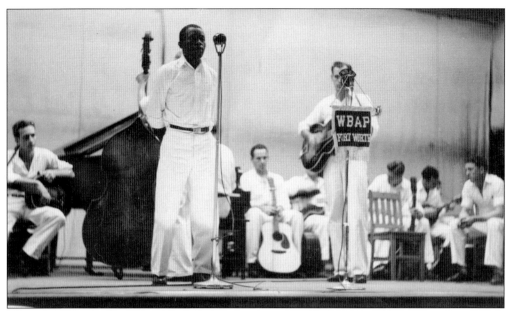

These photographs show convict performers broadcasting from WBAP radio station in Fort Worth for the weekly "Thirty Minutes Behind the Walls." Above is a featured vocalist with a back-up band. Below is a five-piece string band. The live broadcasts, which began in 1934 and remained on air until 1944, were recorded in front of a live audience in the Huntsville Unit beginning at 10:30 on Wednesday evenings. The signal was sent out across the country and into Canada from the Fort Worth station. They regularly had 400 or more audience members at each show, and before the broadcast began, inmates would perform for them.

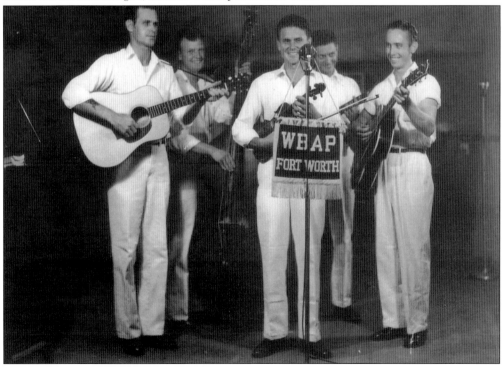

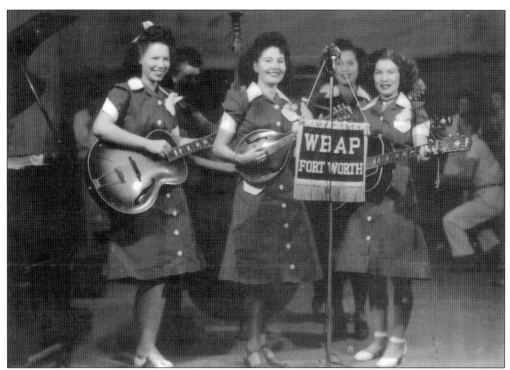

Most of the inmate performers were "trustees," or those earning extra privileges because of good behavior. In addition to music, inmates also gave human-interest interviews about prison life and what they hoped for upon release. Inmate musicians performed a variety of musical styles, including blues, jazz, Western swing, and gospel. Occasionally, comic acts performed. Jack Purvis, a noted jazz musician and one-time member of the Dorsey Brothers, led the prison orchestra while he was incarcerated. Sadly, the radio station destroyed its copies of these recordings. Folklorists Jack and Ruby Lomax preserved a few recordings from their tour of Texas recording prison work songs. The broadcasts were so popular that, on a few occasions, executions were postponed so they would not conflict with the show. The performances were written about in newspapers across the country. In these two photographs are women convicts performing Western swing music. Some of these women would participate in a group known as the Goree All Girl String Band, which would become a favorite at the annual prison rodeo.

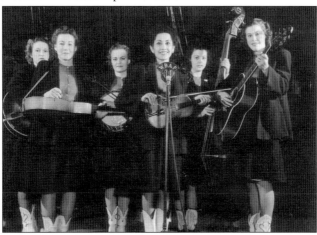

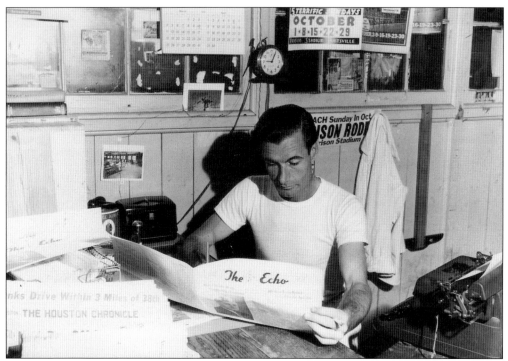

In 1928, inmates were allowed to start the Prison Welfare League, and the *Echo* newspaper was designed to promote good behavior in the prison. Good behavior, they said, was the best route to better treatment and eventual release. By 1929, about half of the inmates in the Texas prison system belonged to the Prison Welfare League. The *Echo* is still in operation today. This 1949 photograph shows the editor, inmate Emil Block.

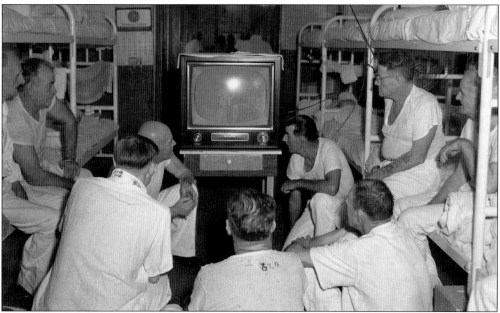

Inmates gather around a television in a dormitory in the Walls. Taken in the 1960s, the men in this photograph are middle-aged or elderly.

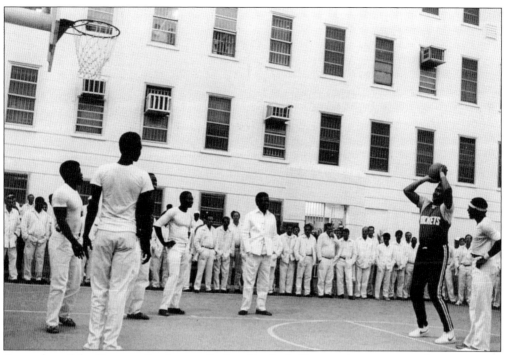

A member of the Houston Rockets professional basketball team plays a game with inmates.

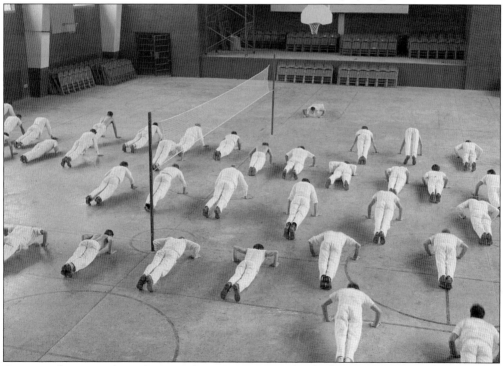

A group of inmates do pushups in the gymnasium at the Walls. Inmates were allowed weekly exercise time, which, depending on their behavior, could include access to the gymnasium and other activities.

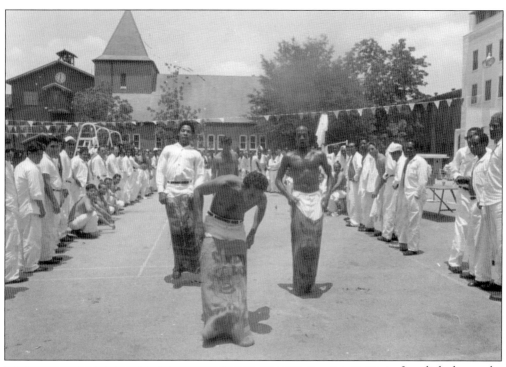

In a light-hearted moment, inmates participate in a potato sack race in the yard.

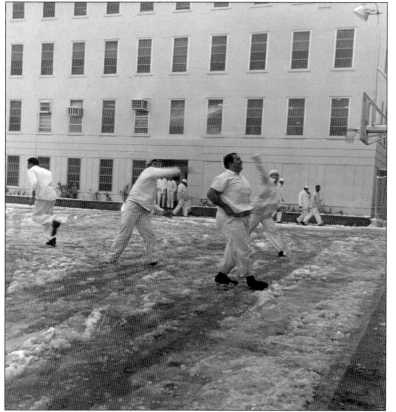

Although rare, Huntsville occasionally sees some snowfall. These inmates photographed in the 1970s are enjoying a snowball fight in the courtyard during their recreation time.

Six

PRISON RODEO

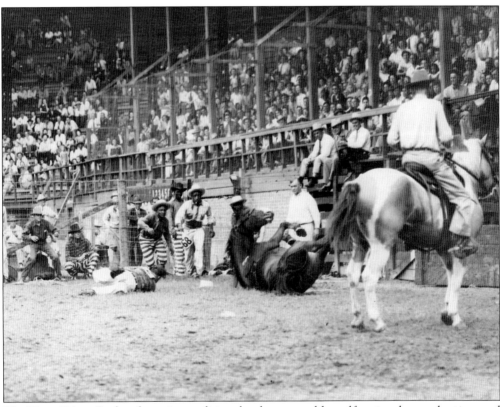

The Texas Prison Rodeo, featuring traditional rodeo events like calf roping, bronco busting, and bull riding, drew large crowds. Other, more nontraditional events included wild-cow milking and wild-horse racing. One favorite was an event where a convict tried to grab a sack of money that was tied between a bull's horns. When it began in 1931, the rodeo was held in the baseball field behind the prison. It was designed to provide some recreation and entertainment for both inmates and prison employees. It proved so popular, though, that it was opened to the general public. The Texas Prison Rodeo was held every Sunday in October. In this photograph, a bucking bronco has just tossed off its convict cowboy rider.

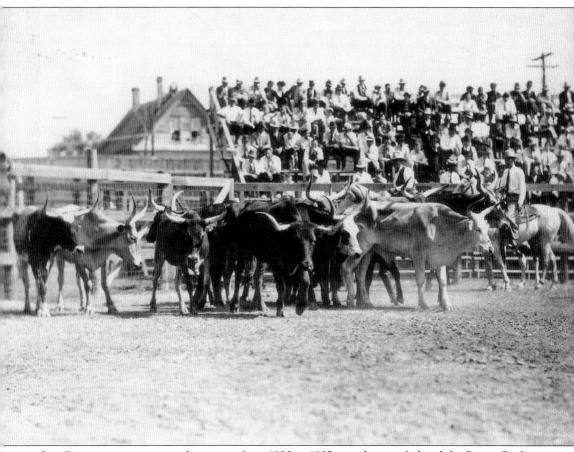

Lee Simmons, prison general manager from 1930 to 1935, was the man behind the Prison Rodeo. Before beginning his career with the prison system, Simmons served as sheriff of Grayson County. Gov. Pat Neff ordered a detailed investigation of the prison system in 1923. (Reforming the prison system was a favorite political topic among gubernatorial candidates in Texas.) Simmons's investigation uncovered many shortcomings, and Neff's successor, Gov. Dan Moody, appointed Simmons to the prison board. In 1930, he took over as general manager. Focusing on boosting morale and improving conditions for inmates and guards, Simmons began renovations on the Huntsville Unit. He started several programs to change the public impression of the prison system. The rodeo was a big part of this plan, as were the prison baseball team and the inmate radio program *Thirty Minutes Behind the Walls*. After the foundation was laid by Simmons during his time as general manager, the rodeo continued to grow in subsequent years. By the 1960s, the rodeo regularly drew crowds of 100,000 or more. It brought in much-needed revenue to both the prison and the town of Huntsville, which benefitted from increased tourism. The Texas Prison Rodeo ended in 1986. In this 1934 photograph (one of the earliest of the Texas Prison Rodeo), Lee Simmons can be seen on the right, on horseback.

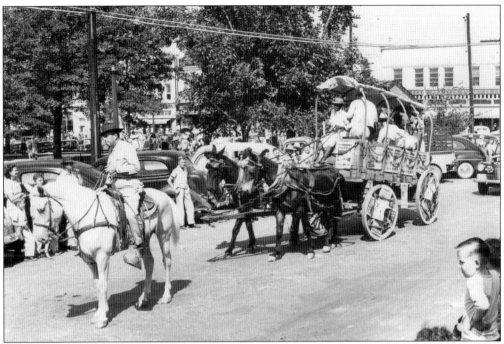

The Texas Prison Rodeo kicks off with a convict parade through the streets of Huntsville. Two prison mules pull the convict wagon. Mules were an important part of the prison system, especially on the prison farms.

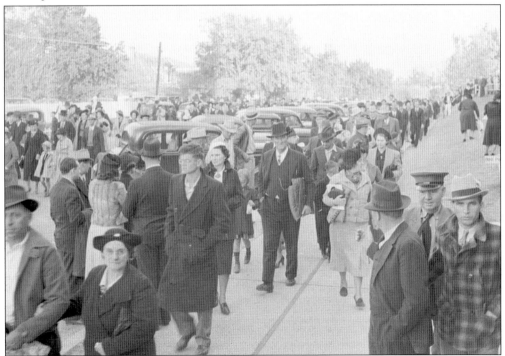

The Prison Rodeo drew large crowds to Huntsville. These people are heading toward the rodeo arena.

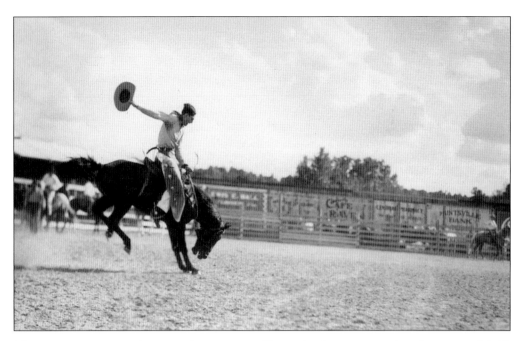

These two convict cowboys are doing an excellent job of staying on their bronco and bull. Interestingly, many of the postcards produced about the rodeo focused on inmates that were being tossed or stomped by rodeo animals.

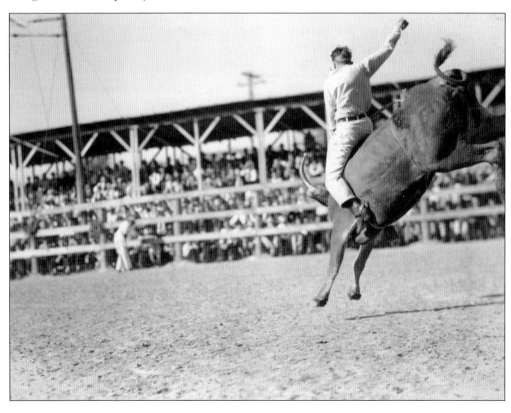

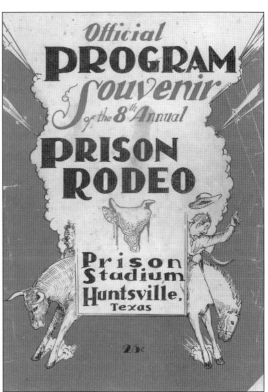

Two Texas Prison Rodeo programs from the 1940s are shown here.

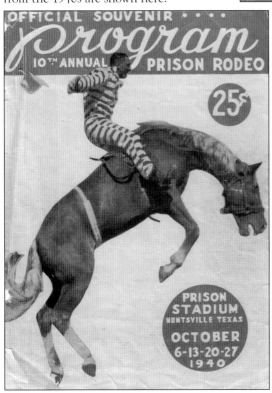

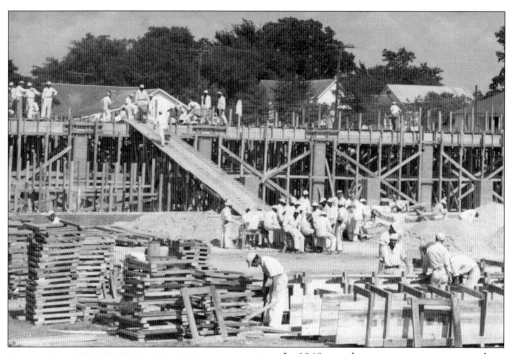

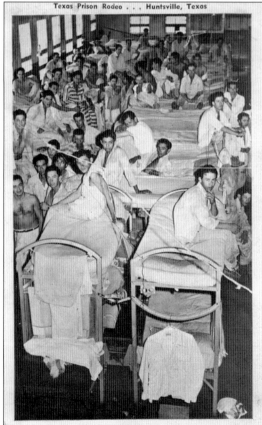

Texas Prison Rodeo . . . Huntsville, Texas

In 1949, a rodeo arena was constructed using convict labor. In this photograph, inmates work diligently to complete the ambitious project. The rodeo arena was torn down in January 2012, and the bleacher seating was covered over, creating a slanted roof. The area underneath the bleachers was converted to a dormitory for trustee inmates.

This postcard shows a bunkhouse crowded with inmates from around the state who have come to Huntsville to participate in the rodeo. The men seem excited to be in town for the event.

A spectator took this photograph from the rodeo bleachers in 1957. Inmate spectators are seated in the distance, to the right, and cowboy inmates are walking in the center of the arena. The prison is visible beyond the arena.

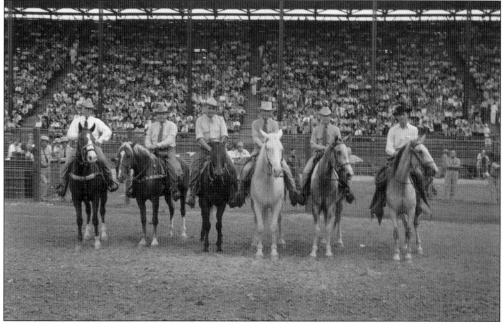

An array of rodeo judges poses for a photograph before the festivities begin. The prison brought experienced rodeo judges from around the state to participate.

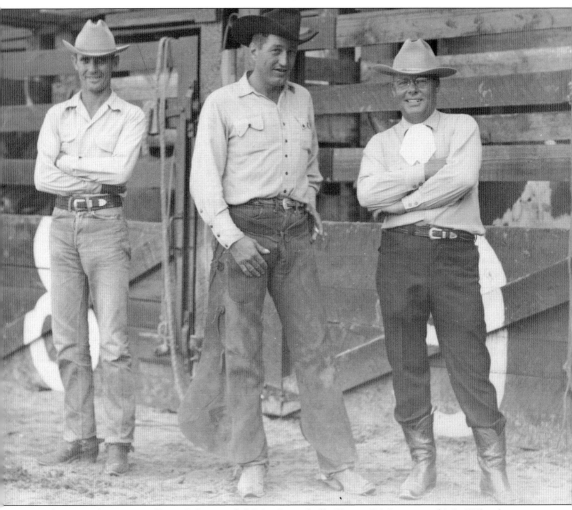

Three "pickup men," (from left to right) Mr. Campbell, "Buster" Moore, and Mr. Wheelis, pose at the rodeo in the 1950s. The pickup men help the rough stock riders dismount safely after their eight-second rides are over; they travel the rodeo circuit performing this highly skilled and dangerous job.

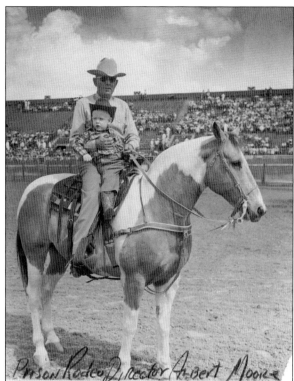

At right, Albert Moore holds a small boy in front of his saddle as he supervises the Texas Prison Rodeo. Moore, the welfare director of the prison, did much of the planning and organizing for the rodeo. Below, he is pictured again with Capt. Joe Byrd (right), in front of the new rodeo-stand construction.

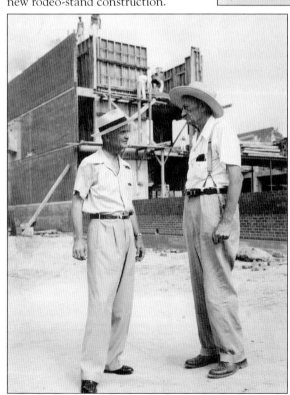

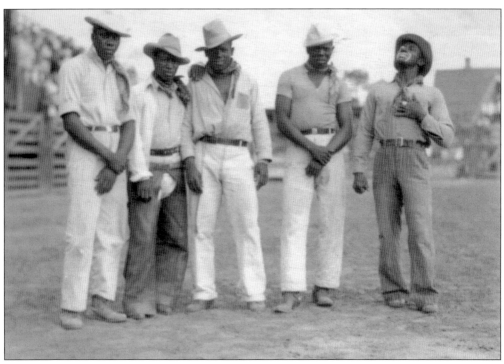

Above, black convict cowboys and a clown pose in this photograph. Below, a rodeo clown sits in front of a convict band that will perform at the rodeo. The Goree Girls are in the back row.

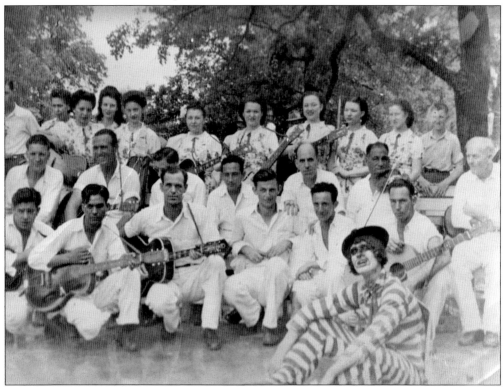

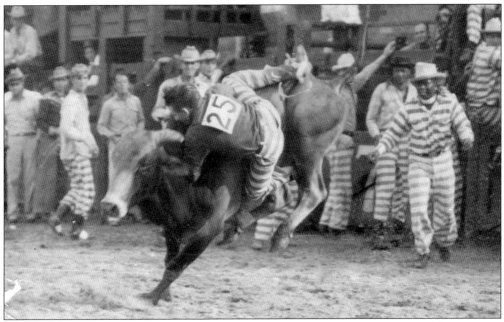

The postcard on the top shows convict bull riders competing in the Texas Prison Rodeo. What began as a way to reward convicts for good behavior quickly turned into a popular public amusement. In the postcard on the bottom, a convict is clinging to a bull, while a group of inmates dressed in red shirts sits behind a fence on the left. The inmates in red were the participants in a contest to grab a sack of money that was tied between a bull's horns. The Prison Rodeo began in 1931 and lasted until 1986, drawing thousands of spectators each year and featuring performances by big-name country music acts.

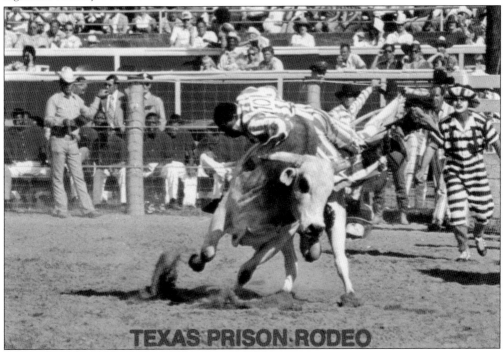

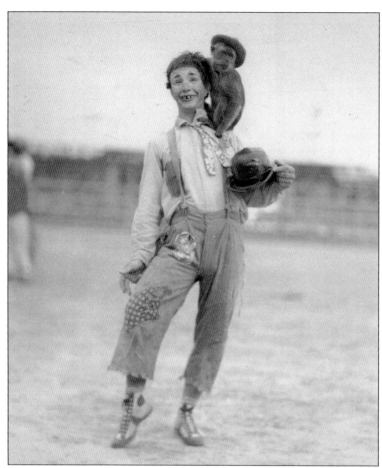

This convict rodeo clown performs with Pedro the monkey. Pedro, who was notorious around the prison and popular with rodeo spectators, is buried in the prison cemetery.

Sweet Pea the Educated Skunk is held by the rodeo clown in the center of this photograph. The clowns were a popular part of the show. The man wearing blackface is an indication of the racial issues prevalent in Texas at the time.

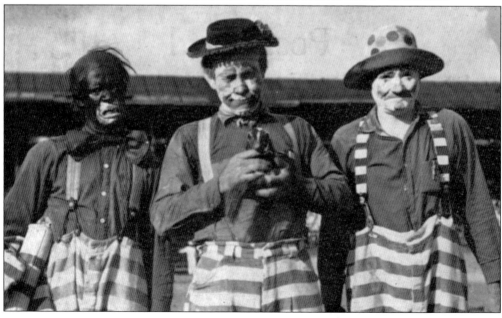

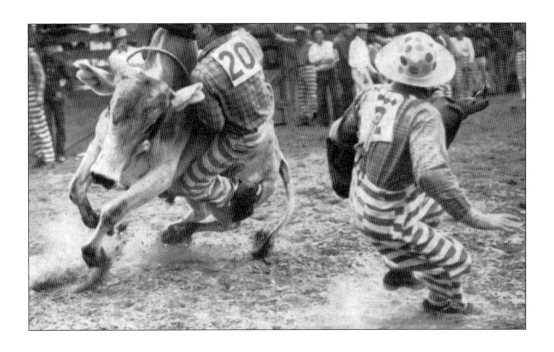

The photograph above shows a convict wrestling a steer, a contest also called bulldogging. Below shows a humorous "mare-milking" event.

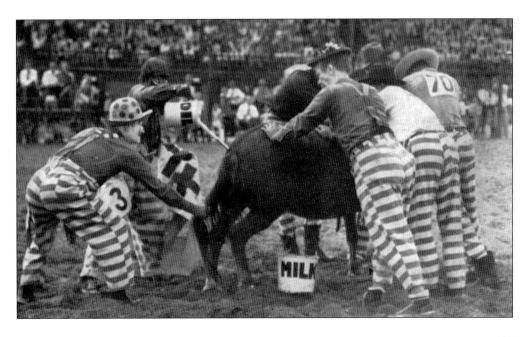

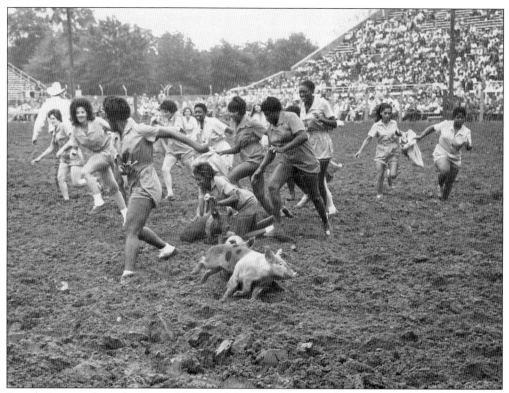

Female inmates from the Goree Unit participate in the greased pig contest. Several pigs would be released and the women would try to catch them, stuff them in a burlap sack, and carry them to a center ring to claim a prize. In this second image, "Miss Dallas" of 1949 seems to be enjoying the ride in the "chariot race."

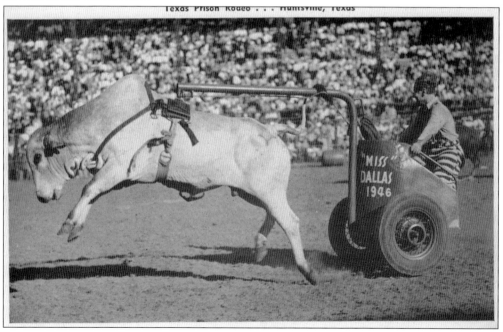

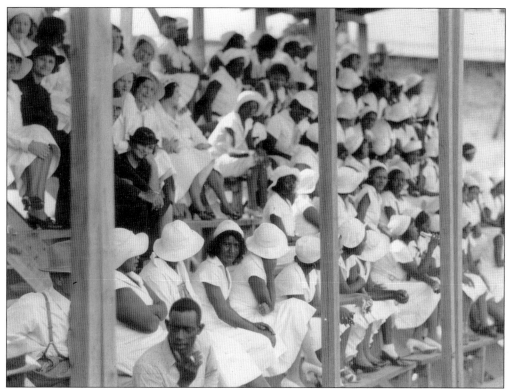

Inmates that had a clean behavior record were allowed to attend the rodeo as spectators. In this photograph, women inmates from the nearby Goree Unit watch from the stands.

Members of the Cotton Pickers Glee Club were hand selected by prison manager Lee Simmons in the early 1930s. Simmons visited prison units across the state looking for the most talented incarcerated men. He transferred these men to Huntsville, where they performed at the rodeo and also traveled to various locations to sing. In this c. 1935 photograph, the Cotton Pickers Glee Club poses in the Rodeo Arena. Lee Simmons stands to the far right, and next to him is Ray Chapman, who led the glee club.

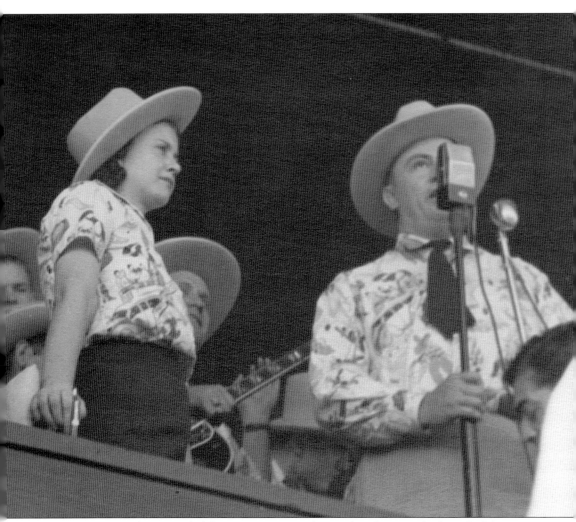

Texas governors often attended the Texas Prison Rodeo. In this photograph, the colorful governor Wilbert Lee "Pappy" O'Daniel addresses the crowd. O'Daniel was governor from 1939 to 1941. Before entering politics, he had worked for Burrus Mills, a company that produced flour. To help advertise the brand, he created a singing group called the Light Crust Doughboys, for whom he wrote the songs. The group performed "old-timey" music on the radio. O'Daniel became so popular that he started his own company, O'Daniel's Hillbilly Flour, and a new band, Hillbilly Boys. His radio work earned him the nickname "Pappy" and helped propel him into politics. He also served in the US Senate, narrowly beating Lyndon Johnson in 1941. It was a controversial election, with many accusations of voter fraud and vote buying.

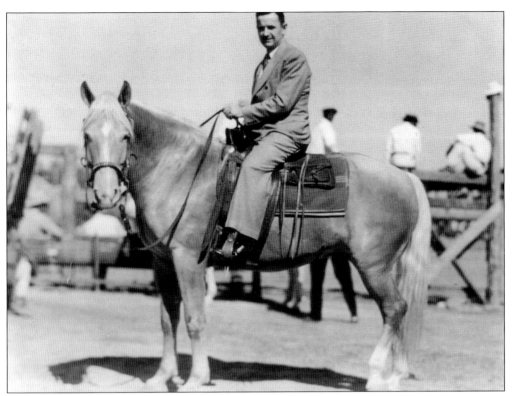

Gov. James Allred, who was in office from 1935 to 1939, sits on a horse at the rodeo. Prior to his two terms as governor, Allred was the attorney general of Texas. Following his governorship, he became a federal district judge.

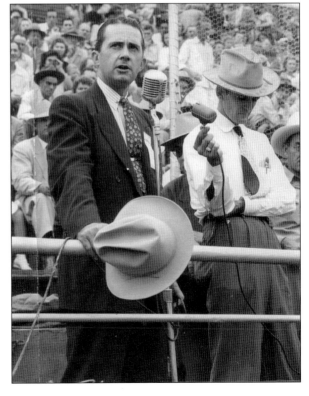

Gov. Allan Shivers speaks to the crowd at the rodeo in the early 1950s. Shivers had served as lieutenant governor under Beauford Jester, and became governor upon Jester's sudden death in office in July 1949. He remained in office until 1957. Texas governors enjoyed talking to their constituents at the Prison Rodeo.

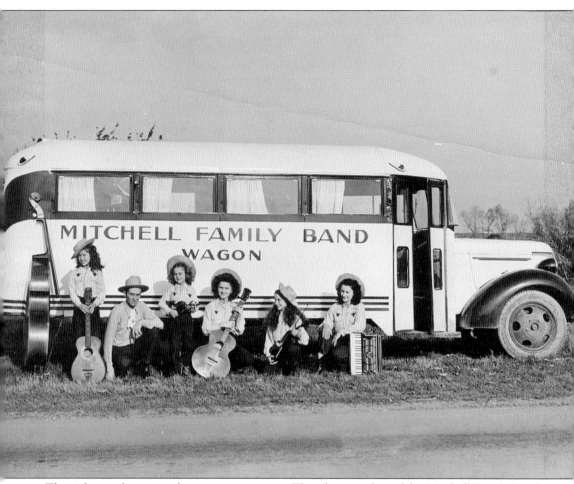

The rodeo used many civilian acts to entertain. This photograph is of the Mitchell Family Band, a popular Texas string band. Father Byron played the upright bass, and mother Elvera played the accordion. Eldest daughter Peggy Jean and her sister Margaret Evelyn were both crowned as "Queen of the Texas Fiddlers Association" in 1948 and 1949, respectively. Nina Elizabeth was a "trick fiddler" and the youngest daughter, Patsy Ruth, sang and played drums. Pictured from left to right are Margaret Evelyn, Byron, Patsy Ruth, Peggy Jean, Nina Elizabeth, and Elvera.

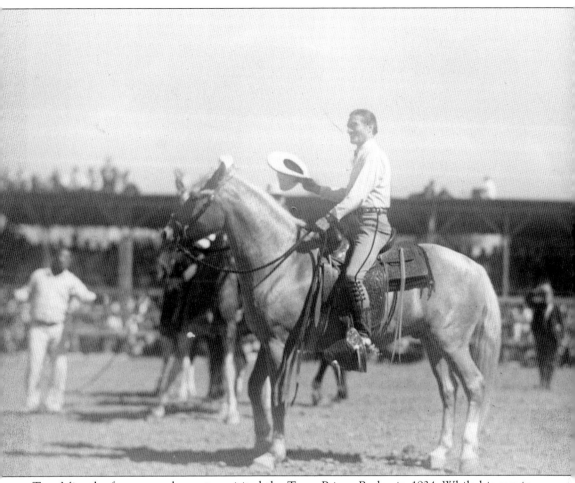

Tom Mix, the famous cowboy actor, visited the Texas Prison Rodeo in 1934. While his movie career ended soon after this visit to Huntsville, Mix starred in almost 300 films, most of which were silent movies. Before getting into acting, Mix served in the Army and worked on a ranch in Oklahoma. Although his horse was nearly as famous as he was, he did not bring Tony "the Wonder Horse" to the rodeo.

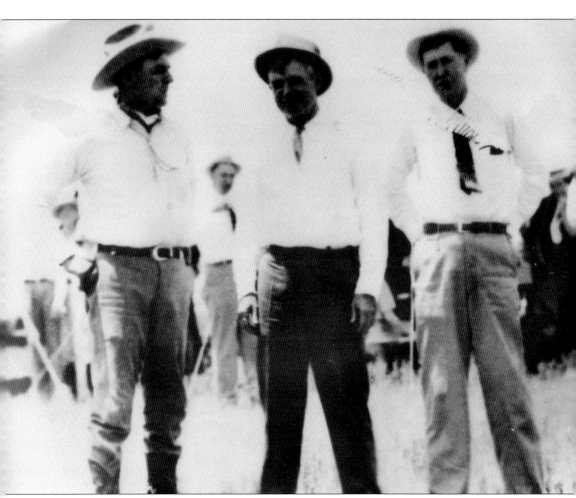

Will Rogers (center), the famous humorist, appeared at the rodeo around 1935. Here, he stands with Capt. Tom Hickman (left) and Lee Simmons. Rogers was one of the most famous people in the United States during the 1920s and 1930s. He began in vaudeville then went on to the Ziegfeld Follies and movies. He died in a plane crash in Alaska in 1935, not long after his visit to the Texas Prison Rodeo.

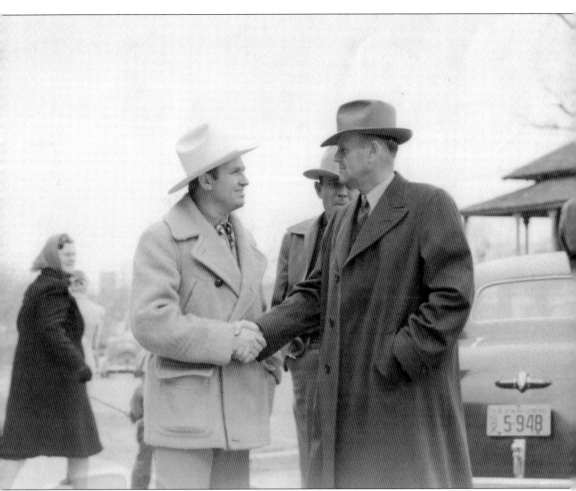

Gene Autry (left), the singing cowboy, visited the Prison Rodeo in the early 1940s. The star of film, radio, and television is pictured here with general manager Douglas Stakes. Autry starred in nearly 100 films and released hundreds of records, but despite being known primarily as a singer and actor, he also had a great love of rodeos. In the early 1940s, he purchased part ownership in a company that provided livestock to rodeos across the country, including the Texas Prison Rodeo. He remained involved in the rodeo business for the rest of his life and was inducted into the Professional Rodeo Cowboys Association Hall of Fame in 1979.

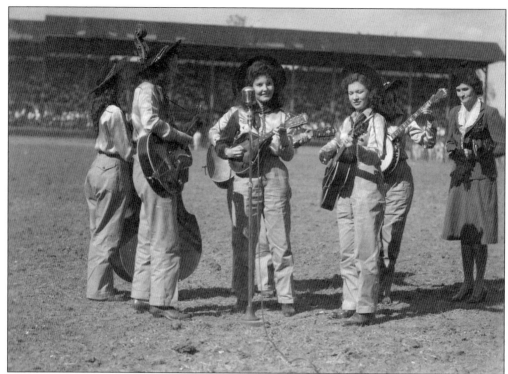

Goree All Girl String Band performed country swing music on the prison radio program and at the Prison Rodeo. They were extremely popular and had a nationwide following. As members left prison, new women convicts replaced them. Above, the Goree Girls perform at the rodeo as a prison matron stands nearby. Below, they are dressed in gypsy costumes.

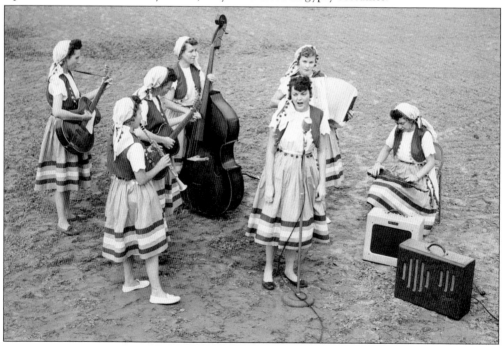

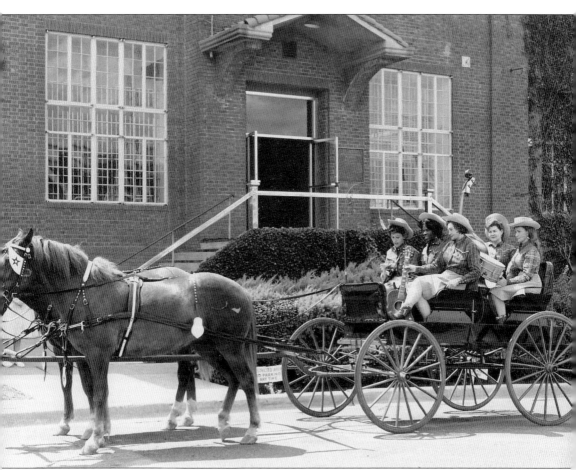

The Goree Girls pose in a horse-drawn wagon in front of the administration building on their way to another rodeo performance. Because the group is not segregated, this photograph is likely from the mid-1960s.

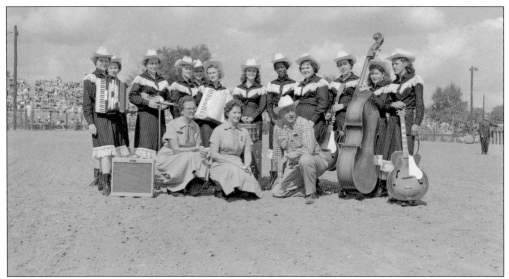

Roy Dillon, longtime announcer for the Prison Rodeo, poses with the Goree Girls in 1960. The band was unusually large in number this year, even including two accordion players. The two women kneeling in front are prison matrons at the women's prison.

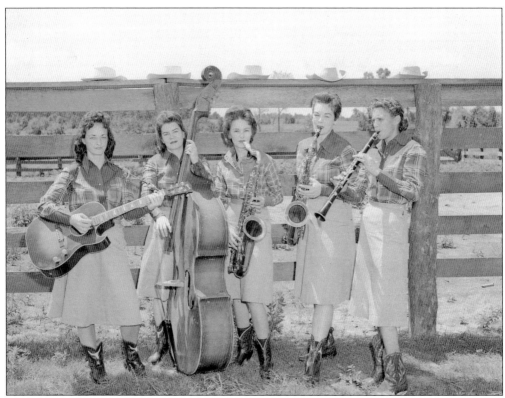

In this 1963 photograph of the Goree Girls, it would seem that the bass player pictured second from the left is the same woman pictured second from the right in the top photograph. Originally a string band, the group expanded to include horns.

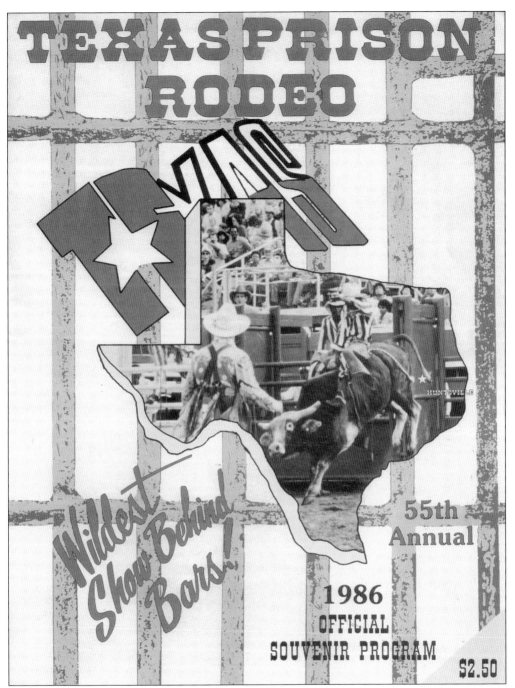

This is the program from the last Texas Prison Rodeo, in 1986. Attendance had dropped steadily in the early 1980s, and the event had become increasingly expensive to produce.

DISCOVER THOUSANDS OF LOCAL HISTORY BOOKS
FEATURING MILLIONS OF VINTAGE IMAGES

Arcadia Publishing, the leading local history publisher in the United States, is committed to making history accessible and meaningful through publishing books that celebrate and preserve the heritage of America's people and places.

Find more books like this at
www.arcadiapublishing.com

Search for your hometown history, your old stomping grounds, and even your favorite sports team.